The College History Series

THE VIKING TRADITION
100 YEARS OF SPORT AT
BERRY COLLEGE

To An Athlete Dying Young

The time you won your town the race
We chaired you through the market-place;
Man and boy stood cheering by,
And home we brought you shoulder-high.

To-day, the road all runners come,
Shoulders-high we bring you home,
And set you at your threshold down,
Townsman of a stiller town.

Smart lad, to slip betimes away
From fields where glory does not stay
And early though the laurel grows
It withers quicker than the rose.

Eyes the shady night has shut
Cannot see the record cut,
And silence sounds no worse than cheers
After earth has stopped the ears:

Now you will not swell the rout
Of lads that wore their honours out,
Runners whom renown outran
And the name died before the man.

So set, before its echoes fade,
The fleet foot on the sill of shade,
And hold to the low lintel up
The still-defended challenge-cup.

And round that early-laurelled head
Will flock to gaze the strengthless dead,
And find unwithered on its curls
The garland briefer than the girl's.

A.E. Housman
1895

The College History Series

THE VIKING TRADITION

100 YEARS OF SPORT AT BERRY COLLEGE

SUSAN J. BANDY, PH.D.

ARCADIA
PUBLISHING

Published by Arcadia Publishing
Charleston, South Carolina

Printed in the United States of America

Library of Congress Catalog Card Number: 2002111303

For all general information contact Arcadia Publishing at:
Telephone 843-853-2070
Fax 843-853-0044
E-Mail sales@arcadiapublishing.com
For customer service and orders:
Toll-Free 1-888-313-2665

Visit us on the Internet at www.arcadiapublishing.com

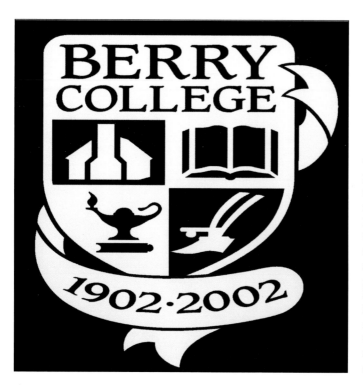

THE CENTENNIAL VERSION OF BERRY SHIELD. The shield of the college was designed many years ago by Martha Berry, the founder of the school. The cabin is for simplicity, the Bible is for spiritual development, the plow is for labor, and the lamp is for learning. She intended these emblems to represent and focus on the ideals of the school and those for which the students should strive.

CONTENTS

ACKNOWLEDGMENTS

This book has been a collaborative effort on the part of so many people who have a relationship to Berry College, either as former students and athletes, employees, or friends of the college who care about its history. It simply required a more expansive and detailed knowledge of the history of the college and the history of sport at the college than I had when I began the research in the summer of 2000.

Of critical importance when writing books are those with whom one first shares one's ideas, for their acceptance seems somehow necessary in order to go further beyond the "idea" of a book. To Ouida Word Dickey, I will remain deeply grateful for her immediate and enthusiastic acceptance of the idea when we first discussed it in December 1999. Her support, in a variety of ways, has been invaluable. Most importantly, her knowledge of the history of Berry, her careful research, and her meticulous editing enabled me to create a more accurate and refined book. Susan Asbury Newsome, with whom I also worked closely, provided support in a variety of ways. In addition to discussing the book at length in the early phase of the research, she provided many forms of technical assistance and student workers who assisted me by doing research, photocopying, and typing. Of particular importance was Ashley Bowden whose interest in the book, careful work, and imagination were so beneficial.

Many people helped me to piece together this history that I did not know from my own experience or could not find in the archives. Charles Acree, Vincent Mull, and Doris Dickey provided information about the 1930s, 1940s, and 1950s respectively. To others I owe thanks for information about the last 30 years. I often referred to the work of Paul Marks, sport journalist, who was the first to write about the history of sport at Berry. I would also be remiss if I did not thank Lorenzo Canalis, Paul Deaton, and George Gallagher, who, as coaches, shared their knowledge of the recent years and my enthusiasm for the book. And, lastly, the information provided by Bob Pearson and Jeff Gable assured that the history of the last two decades of the Viking Tradition could be told.

Others at Berry and at the publisher were equally supportive. I owe thanks to Doyle Mathis and Ruth Ash who shared my view that such a book would be important and assured me that it could actually be done. President Scott Colley's approval on behalf of the college was necessary for the publication of the book, and I am grateful that he could see the merit of such a work. The proposal was soon accepted by Arcadia Publishing, and Katie White, publisher and editor, readily approved the book as worthy and appropriate for the press. In the months to follow, I was able to work with her easily and confidently. In the final stages of the book, Rebecca Roberts and Amy Summerlin of the Archives enabled me to complete the book by searching for obscure historical facts, scanning photographs, and providing support in numerous other and important ways. Kathy Clements gave a touch of art and beauty to the book that matched my ideas about Berry and ensured some internal continuity from period to period. I am grateful as well to Bill McAdams, who reminded me of the poem by A.E. Housman and then helped me to see the way in which it connected the story and then to understand the importance of telling the story.

INTRODUCTION

In 1902, Martha Berry founded the Boys Industrial School, and seven years later girls were admitted. The school grew from a mountain industrial school into a two-year college in its first 24 years and became a four-year college in 1930. Intent on teaching the "dignity of labor and the economy of time," Martha Berry created an institution with a rather unique focus of combining an industrial and academic education coupled with practice and based on Christian principles.

Soon after the school opened, sport emerged alongside other student-sponsored societies, clubs, and extracurricular activities that provided a rich campus life, complementing the educational and training programs of the school. The emergence of sport at the school seems a rather natural occurrence in the United States in the early 20th century. Soon after the first colleges were established in the 17th century, sporting activities were begun by the students and soon developed into intercollegiate competition in the 18th century. With the ever-increasing popularity of sport in the United States in the 20th century, student interest in baseball, basketball, and track and field at the school reflected the growing popularity of these sports in the American culture in this era and the well-established relationship between sport and education that continues to flourish in contemporary society.

The history of sport at Berry, in all of its forms—intramural and intercollegiate competitions as well as recreational pastimes—is the subject of this book. Although the early appearance of sport at the college and its intimate relationship with education seem rather natural, the development of sport at Berry has its own distinctive character reflecting the uniqueness of the school's mission as well as the influence of the three individuals who fashioned the development of sport in its 100 years: Samuel Henry Cook, Garland M. Dickey, and Bob Pearson. This history rather divides itself according to their influence into the formative years of sport at the school, the years of the rebirth and development of intercollegiate sport, and the expansion of the sports program respectively.

The first few years serve as a prelude; boys and young men played baseball and basketball with neighboring teams and swam in the Oostanaula River in the summer. To promote their sporting passions, they formed the YMCA and the Athletic Association. They then built a running track and basketball court on the campus and voiced their interest in building a gymnasium. In 1909, when women enrolled, they, too, began to create a sporting culture of hiking, dancing, and physical drills that was typical for young women in the early 20th century.

The formative years were those of Samuel Henry Cook who came to Berry in 1910. Although Martha Berry did not seem to strongly support competition in sports, she was eager to promote the health of the students. She hired Cook to come to the school to head the department of mathematics and to teach courses in physical culture, which was a requirement of all the male students. Some years later an instructor was hired to teach physical culture for the female students. The relationship between sport and education was strengthened with the requirement of classes in physical culture and a sports program that moved beyond local competitions to regional competitions with other schools. Young men at Berry ran for the "Silver and the Blue" in Chattanooga and Atlanta and played in their first basketball tournament at Auburn. Sporting rituals became firmly entrenched as a part of campus life when Field Day was celebrated with processions, music, and queens who crowned victors. The young women began their sporting traditions with inter-class competitions in basketball and volleyball and established their own

Field Day traditions as well. The World Wars, the Depression, and the banning of intercollegiate sport by the Board of Trustees interrupted the development of intercollegiate competition during these years; however, intramural competition endured and sustained the sporting spirit at the college until the end of the Second World War.

In the summer of 1946, Garland Dickey returned to his alma mater to become the first full-time athletic director and teacher of physical education. With his brother, Edward, he re-established intercollegiate competition, and the "Silver and the Blue" gave way to the "Blue Jackets," as the Berry athletes came to be known. During the 35 years of his tenure, Dickey expanded the sports program from one sport to seven, the school became a founding member of the Georgia Intercollegiate Athletic Conference, and the Viking was chosen as the school symbol. The tradition of Field Day continued to be contested and eventually developed into an intercollegiate team in track and one in cross-country. The tradition of intramural competition in basketball for women, begun in the 1920s, gave the athletic program at the college a unique dimension in the 1960s. The school developed an intercollegiate program for women in basketball and volleyball when few schools offered such programs. The college entered yet another level of competition when the Lady Vikings brought home the national crown in basketball in 1976.

With the passing of Garland Dickey, Bob Pearson came to the college in 1982 to head both the athletic program and the physical education department. Soon after he arrived, he began to leave his mark on the program as one of expansion and a movement toward equality among sports and between male and female athletes and a balance between intercollegiate and intramural competition. He brought intercollegiate golf and baseball back to the program and added a women's soccer team soon after he arrived. To meet the needs of the expansion of the program, new soccer fields were added, the tennis complex was enlarged, and the golfers were able to compete on a newly built golf course near the campus. With the increasing specialization in sport, the coaching staff expanded in order to have one coach for each sport. The college entered a new conference, the TranSouth conference in 1996 and won national titles in women's soccer and men's golf. The school now claims five national championship titles and a program that balances an intercollegiate and intramural sports. Fifty-three female athletes and 126 male athletes on 11 teams began the second hundred years of the Viking Tradition in the centennial year.

When the school celebrated its 100th year, those in sport could reflect on a long-standing tradition of sport at the college. As we attempt to capture the Viking Tradition in the following photographs, we may be reminded of the relationship between sport and art. Unlike other art forms, sport is ephemeral and is brought back to us as a subject of art, a tradition that began with the ancient Greeks. With these photographs, perhaps we are able to catch a glimpse of some of those fleeting moments and people who were important to the history of sport at Berry College.

On behalf of those who competed for the Silver and the Blue, the Blue Jackets, and the Vikings, if I may presume to do so, I would like to dedicate this book to the memory of Samuel Henry Cook and Garland M. Dickey and to Bob Pearson, who ensured the sporting traditions of Berry College for 100 years and gave so many of us a place to play.

Prelude
1902–1910

Be a lifter, not a leaner,
Raise high the banners true
This world is not for sluggards,
Our watchwords—Be and Do

"Be a Lifter Not a Leaner"
—Harlan Moore, 1915

Saturday, May seventh, was the gala day of the year for the Industrial School. Thursday and Friday, pies, cakes and bread were baked, hams boiled, and meats roasted; sandwiches were made and other good things were added so Saturday morning well filled hampers were taken to the Southern depot in East Rome where a special car was waiting to take the school to Cave Spring on a day's picnic. Everyone went, boys, teachers, and Miss Berry, while as our guests we had Mrs. C.B. Goetchius, Misses Annie and Mary Goetchius and Miss Martha Carson Harris. The day was a succession of delights for all. The morning was spent visiting the Deaf Institute, exploring the cave and viewing the many picturesque spots of the town.

After the spread of lunch at noon the boys of the ball team made themselves ready and at 2:30 a game was called between our team and that of Hearn Institute. The game was intensely exciting, being well played and fairly umpired. The score stood six to nine in favor of the Industrial School. This victory was very gratifying and put us all in splendid humor for the final treat of the day which was the lecture delivered by Ex-Governor Bob Taylor at the Rome Opera House. Our train reached the city at eight p.m. and we went immediately to the opera house where seats had been reserved for us.

From this account of one of the school's earliest sporting contests in 1904, we have a glimpse of sport at the school and of its place in the life of the students. Sport arose in the context of leisure as an integral part of school life and its celebrations and more simply as a recreational pastime of the students in the early years of the 20th century. It was through the efforts of the students themselves that sport began at the school, as it had at most colleges in the United States from the earliest origins of intercollegiate sport in the 18th century. It was common practice for students to organize, coach, and participate on teams in the early years of intercollegiate sport in the United States.

Very soon after the school opened, students created organizations to promote sport. In 1902, the Young Men's Christian Association was founded, and it was through this association that students would be able to compete against other teams, which were often associated with the YMCA. Thereafter, the students organized the Athletic Association to "promote and control athletics at the school, under the supervision of the faculty."

The structure for intramural competition was also created in the form of inter-dormitory competitions between Brewster, Glenwood, and Inman Halls, and the Cottages. From these dormitory competitions, a "varsity" team was chosen to represent the school when it was allowed to compete with other schools.

The boys also formed a football team that played local teams; however, football was short-lived at the school because of Miss Berry's concern that it was a dangerous sport. Baseball, basketball, and track were the popular sports, and the boys built a field, a court, and a track on the campus of the school.

Inter-dormitory competitions included all three sports—baseball, basketball, and track—and such competitions sustained competitive sport on the campus in later years when the trustees banned sports competitions with other schools, which they did on several occasions until the mid-1940s. Typically, the inter-dormitory series in baseball was conducted in the fall, followed by the series in basketball. The annual Field Day, which celebrated and honored athleticism in track and field, was initially held once a year in the autumn. It was soon held twice a year in the autumn and then again in the spring. Held annually until 1965, Field Day remains the longest continued sporting event in the history of sporting traditions at Berry College.

In 1909, the school admitted women, and very soon after they arrived they began to form their own sporting culture. The earliest accounts of their activities include hikes to Lavendar Mountain and various forms of exercises, drills, and dances.

As this brief, introductory phase of student-created sport at the school came to an end in 1910, the faculty claimed all final control of sport and established academic standards for its athletes—a general average of 80 and a passing mark in all studies. The intense desire and love of sport on the part of the students, however, ensured the continuation and expansion of sport that was to follow. The sporting rituals had been created, and the hallowed ground on which they would be performed had been carved out of the land.

In 1910, the school announced that physical culture, drills, exercises, and gymnastics would be given the next year, under a competent physical director, and would be required of all students. The competent physical director whom the school hired was Samuel Henry Cook, who would fashion sporting life at the school for the next 35 years.

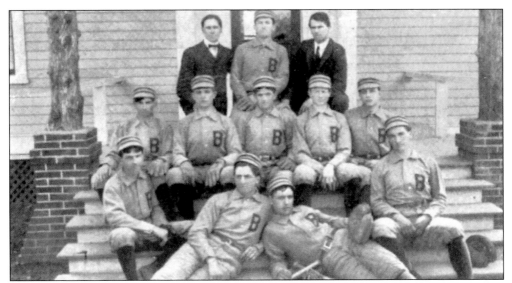

BASEBALL TEAM, 1904. In April 1904, Berry's first baseball team defeated a team from Trion, Georgia, by a score of 4-3; in May, they defeated Hearn Academy of Cave Spring, Georgia, 9-6. Shown on the porch of Brewster Hall, the team was managed by A.S. McClain, the head of the Industrial Department; William Rutherford Coile was the faculty representative and Will Moseley was the team captain. From left to right are (first row) B.E. Neal and Will Moseley; (second row) Frank Whitlow and J.W. Weaver; (third row) Reno Tucker, Jesse Graham, Joe Wynn, Whit Henry, and R.G. Williamson; (fourth row) A.S. McClain, J.W. Cooper, and William Rutherford Coile.

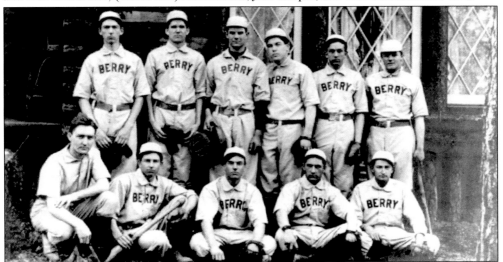

BASEBALL TEAM, 1907–1910. Pictured here is the "varsity" baseball team that competed with other schools from 1907 to 1910. The varsity team was selected from the most outstanding of the inter-dormitory series, which first took place as early as 1905. In the same year, the students built a baseball field. Prof. W.M. Price Wright, who also played shortstop, coached the team and Marvin H. Killingsworth, who played the outfield, was the business manager. From left to right are (first row) Coach Wright, two unidentified, Charles Arthur Milhollan (pitcher), and Marvin H. Killingsworth; (second row) Bernie Levine Frost (first base), Ed Woolly (third base), Percy M. Pentecost (catcher), Jesse W. Tucker (second base), Reno Robert Tucker (short stop), and David Roses Peacock (utility).

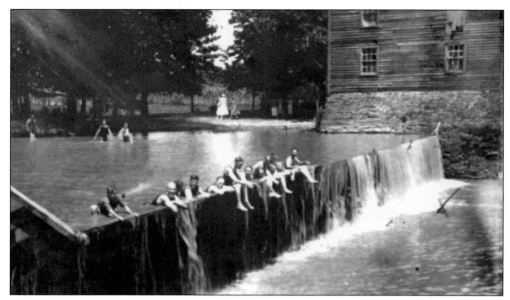

SWIMMING ON THE FOURTH OF JULY. Swimming was popular with the students during the summer months, and the Oostanaula River replaced the "old swimming hole." Eventually, students could swim in their own Victory Lake, which was completed in 1921, and later in the indoor pool in Memorial Gym, which was completed in 1937. According to school regulations, no students were allowed to go swimming without an officer who was appointed by the faculty to ensure their safety. Students are shown on the Oostanaula on the Fourth of July in the school's early years.

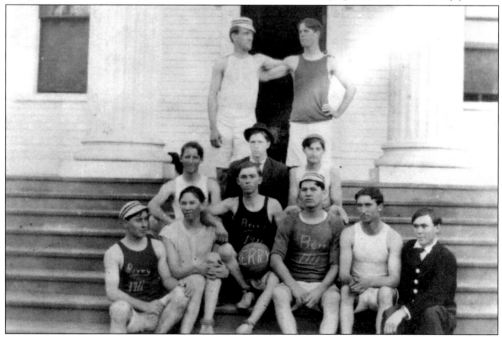

BASKETBALL TEAM 1907–1910. Pictured above is one of the first basketball teams at Berry, which played local teams from 1907 to 1910. They are shown here on the stairs of the Recitation Hall, which became the Administration Building and was later named the Hoge Building. On the shirts of several players is the year 1911, signifying the year of their graduating class.

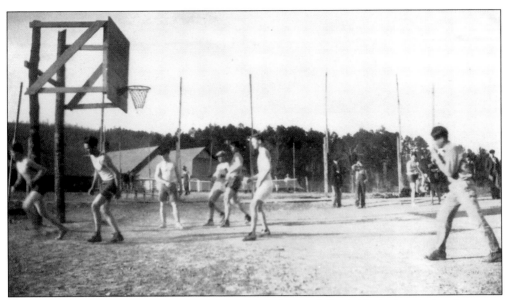

FIRST BASKETBALL COURT. As early as 1905, the students of the Athletic Association began to construct athletic fields on the campus. In addition to a track and a baseball field, the basketball court shown above was constructed in 1908. It was used for inter-dormitory competitions, which began at the same time, as well as for "outside contests," as competitions with other schools came to be known.

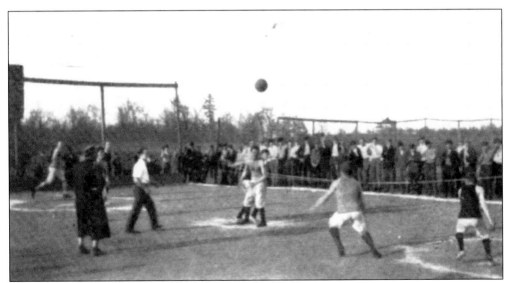

EARLY COMPETITION IN BASKETBALL. The school's first opponent in basketball was Darlington School of Rome, Georgia. The squad traveled to Darlington to defeat the home team by a score of 17-8 in February 1909. After planting the Senior Tree on the campus in March 1909, the Berry team again defeated Darlington 13-7 on the court pictured above. The lineup for the team was as follows: J.W. Tucker (right forward), M.E. Boyles (left forward), P.M. Pentecost (center), D.R. Peacock (right guard), and J.H. Carr (left guard). Pentecost, after whom the first gymnasium was named, scored 15 points at Darlington and emerged as the star of the game.

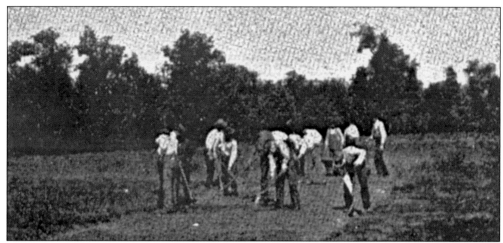

STUDENTS BUILDING THE FIRST TRACK. Students are shown above building the first track on the campus. On October 21, 1907, the first Field Day was held under the auspices of the YMCA. Events of the contest included the 50- and 100-yard dashes, the half-mile, a relay, the standing high jump, standing broad jump, running high jump, and running broad jump. In addition, there was a 100-yard dash for faculty and a small boys' 50-yard dash.

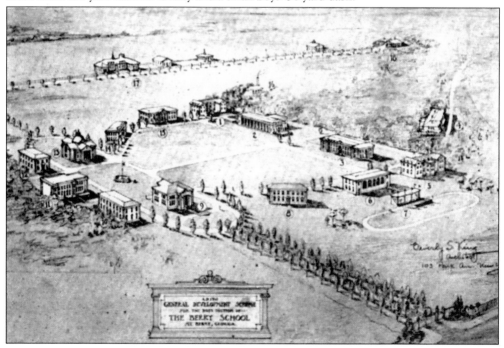

BUILDING PLAN FOR THE BERRY SCHOOL, 1910. Among the new buildings to be requested at the time was a gymnasium. The students constructed the track shown in the field near the entrance to the school in 1908, and Pentecost Gymnasium was constructed later in 1911. The names in italics indicate the buildings that were needed to complete the plan. 1. Crozer Hall, 2. *Dining Hall*, 3. *Dormitory*, 4. Louise Memorial Hall, 5. Emery Hall, 6. *Gymnasium*, 7. Athletic Field, 8. Agricultural Hall, 9. *Recitation Hall*, 10. Science Hall, 11. *Library-Auditorium*, 12. *Administration Building*, 13. *Chapel*, 14. *Manual Training Building*, 15. *Dormitory*, 16. *Power Plant*, 17. Dairy Buildings, 18. Glenwood.

MARTHA BERRY AND ROANY. Accounts of Martha Berry tell of a young woman who loved horseback riding; she also loved tennis and was quite a good player. There were two courts at Oak Hill, where she often played tennis with her friends. She is shown here with her horse, Roany, and her carriage, which she used to travel around the countryside seeking students for her school.

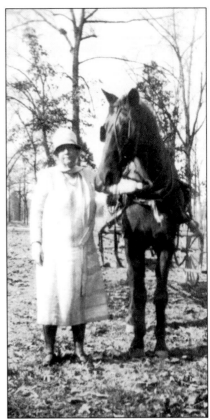

FEMALE STUDENTS IN FRONT OF LOUISE HALL. At the suggestion of Teddy Roosevelt, Martha Berry admitted female students in 1909, and they, like male students, received a practical education. Female students learned to cook and sew, while pursuing lessons in history, math, and other subjects considered important to a basic education. Soon after they entered the school, women had a program of exercises, physical drills, and dance. Pictured below are female students in the school's early years. The girl on the first row (far right) is holding a medicine ball used in early programs of physical culture. From left to right are (first row) three unidentified, Susie Bible, Alberta Patterson (teacher), Rose Peterson, two unidentified, Bessie Ashe, Edna Adams, unidentified, and Annie Sillers; (second row) Pauline Johnson, an unidentified teacher, Eunice White, two unidentified, Lucy Newton (teacher), unidentified, Elsie Adams, Shirley Hamrick, and Mary White.

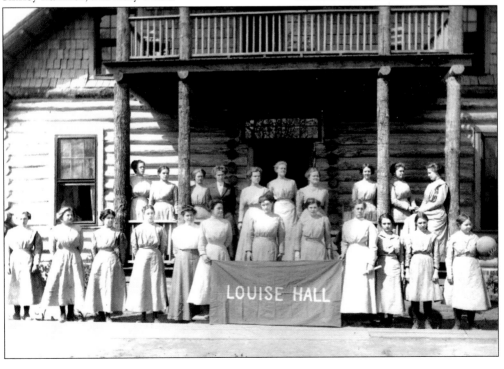

BERRY SCHOOL RECORDS • NOVEMBER 22, 1909

FIELD DAY

50-yard dash, 5 2.5 seconds .Martin

100-yard dash, 10 3.2 secondsMartin

220-yard dash, 25 3.5 secondsBrock

440-yard dash, 59 2.5 secondsBouchillon

One mile run, 5 minutes, 47 2.5 secondsWilliam H. Biggers

Two mile run, 12 minutes, 10 secondsRex Powell

Running high jump, 5 feetPercy M. Pentecost

Running broad jump, 17 feet, 5 inchesCox

Putting 12 lb. Shot, 39 feet, 4$1/2$ inchesWalker

FIELD DAY RECORDS, 1909. Shown above are some of the earliest records and record holders of the Field Day events. Field Day was initially an annual event held in the autumn. Later it was held twice a year, in the autumn and in the spring.

Be A Lifter Not A Leaner

Be a lifter, not a leaner,
 Though slight the lifting be,
The greatesst oaks from acrons grow,
 Small raindrops make the sea.

Be a lifter, not a leaner,
 The lifting may be small,
And yet with many liftings
 Great pyramids grew tall.

Be a lifter, not a leaner,
 Oft-times the way is hard,
But think what is beyond it all—
 God's justice in reward.

Be a lifter, not a leaner,
 A leaner's weakness shows;
In bending from an upright
 The leaner bently grows.

Be a lifter, not a leaner,
 Raise high the banners true,
This world is not for sluggards,
 Our watchwords—"Be and Do."

Harlan Moore
1915

FIRST SCHOOL MOTTO. In the first years of the school, the school motto was "Be a lifter, not a leaner," which inspired this poem by Harlan Moore in 1915. The motto that replaced it was "Not to be Ministered Unto, but to Minister."

One

SAMUEL HENRY COOK AND THE FORMATIVE YEARS 1911–1945

> We ought to have sport at the college
> to develop good athletes
> and good bodies, but even more to
> develop men of good character.
> —Samuel Henry Cook

Twenty Berry Boys—the fleetest of foot of this fleet-footed school—Forded the Georgia-Tennessee State Line Saturday, September the twenty-seventh, and before the local mercuries of Lookout Mountain could lookout, these Boys of Berry put the Chat in Chattanooga, and they are still chattering up there. But unlike the usual chatter, the tale they are telling is not light idle talk, but rather about the jolt, the heavy-scoring Berry Track team gave to the athletes in 'Chattanooga's realm of sport.'

The victorious team with Charles Hamrick, well-known Berry athlete and coach, and with Mr. Cook, the Team Mentor and overseer, spent the night in Chattanooga. But three of the party—Buck Anderson, Manager James Sturdevant, and the writer Forded home to Mt. Berry that night carrying the trophies of victory. After being lost, stuck in the mud and a ditch, flat-tired and soaked we reached the Berry campus shortly before ten o'clock.

The news of the team's success spread rapidly through the dormitories and soon a howling chain of Berry lads were snake dancing over the campus en route to the Girls School one mile distant to let the girls know too, that Berry was not only on the map of Georgia, but very much on the map of Tennessee.

As the previous account of the Berry victory in the track meet at Chattanooga in the *Mount Berry News* of 1924 suggests, intercollegiate sports competition became more regional as track teams traveled to Atlanta and Chattanooga and the basketball team entered its first tournament in Auburn, Alabama. During this era, the sporting culture for men included, in addition to intercollegiate sport, a well-developed program of instruction in classes of physical culture, the earliest form of physical education, as well as a program of intramural competition that would include new sports as well.

The influence of Cook upon the sporting culture of the school was both distinctive and multifaceted. Enamored of what he called the "mystery" of sport, the former half-miler from

Davidson College created many activities, events, and organizations to nurture the already-existing sporting culture on the campus. He would also leave his imprint upon this culture and the sporting traditions of the college.

In addition to planning and supervising a variety of recreational activities for both the men and women at the college, Cook became the first instructor in physical culture, the purpose of which was to develop the "all-around square man—physically, mentally, socially, and spiritually." The courses included calisthenics and drills as well as performed stunts on gymnastic apparatus. These were taught in Pentecost Gymnasium, which was built in 1911. These courses became the basis for the creation of the gymnastics team, which Cook organized to perform during special events at the college. The courses served as well to provide a structure for interclass competitions in basketball. To the ongoing inter-dormitory competitions and Field Day, Cook added an annual three-mile, cross-country run in 1913, an annual tennis tournament, and an annual Thanksgiving Day basketball game. To further promote these competitions, he formed the Varsity Club in 1916 to "arouse a deeper interest in athletics so every boy will strive to win a letter and become a member of the club, which everyone should consider an honor." In 1937, the college built Memorial Gymnasium to provide a new sports facility, which would include a much-needed indoor pool and a more modern basketball court for a return to intercollegiate basketball competition in 1945.

Cook also formed the Athletic Committee, comprised of faculty and staff, to oversee intercollegiate sport. The program of intercollegiate sport was influenced by the war and the decisions of the Board of Trustees, both of which contributed to an interruption in the development of intercollegiate sport at the college. Sport was "war-idled" because students left for service in both the First and Second World Wars. Further interruption came as a result of the decision of the trustees, who banned competition with other schools on three separate occasions—from 1917 to 1919, from 1925 to 1927, and from 1933 to 1945.

Soon after they entered the school in 1909, the women began to create their own sporting culture. Their recreational pursuits included hikes to Lavendar Mountain, swimming at Victory Lake, physical drills, and dance. As early as 1914, they had their own basketball, tennis, and volleyball courts on their campus; and around 1915, the school hired Miss Ellis as the first instructor of physical culture. As was typical of the period, activities in these classes for women included marching, calisthenics, relays, working with light weights, and dance "to develop fit bodies and to add grace to their bodies." Soon thereafter, Alumni Gymnasium was built on their campus; and they formed the Women's Athletic Association to plan their first annual Field Day, held as early as 1923. They also began interclass competitions in basketball and volleyball, and, for the first time in 1926, they, like the boys, played an annual Thanksgiving Day basketball game.

With the completion of Ford Gymnasium in 1931, a well-rounded program of physical education classes, an annual Field Day, and an intramural program had been developed for the female students. This program lacked only one dimension—intercollegiate competition, a program that would not begin for the women until the early 1960s.

In 1946, Berry College hired its first full-time athletic director, Garland M. Dickey, a 1942 graduate of the college, who would return to his alma mater and influence its sporting culture, as Cook had done, for the next 35 years.

SAMUEL HENRY COOK. In the fall of 1910, Samuel Henry Cook came to Berry as the head of the Department of Mathematics and as athletic director. Cook also taught courses in physical culture, formed the Varsity Club and the first athletic committee to oversee sports competition, and served Berry in a number of capacities for over 45 years. Cook is pictured here during his first years at Berry.

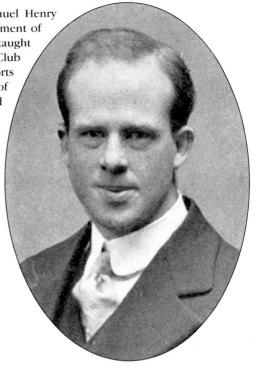

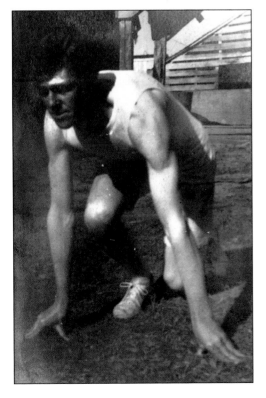

COOK AS A RUNNER. Samuel Henry Cook was born in Brunswick, Georgia. He graduated from the Presbyterian Institute and entered Davidson College in 1905. In 1909, he graduated with an A.B. degree and received an A.M. degree in 1910. He served as the gymnasium instructor at Davidson from 1909 to 1910. A half-miler at Davidson, he developed the first programs in running as well as many other sports at Berry soon after he arrived. This early photo shows Cook as a runner at Davidson College.

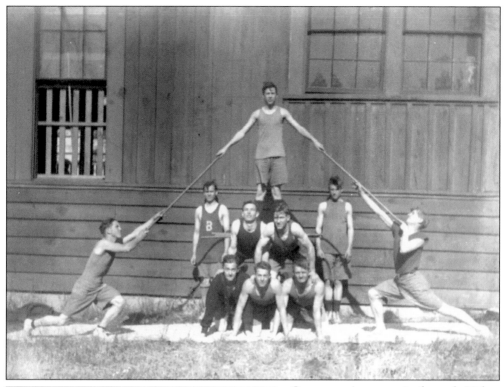

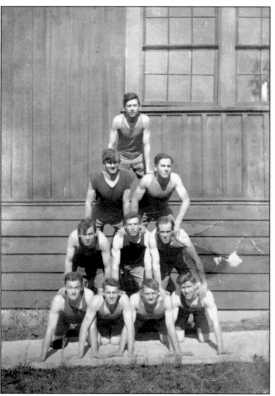

GYMNASTICS ACTIVITIES. In the early 20th century, the activities in programs of physical culture, later to be called physical education, consisted of calisthenics, working on gymnastics apparatus, and stunts and tumbling. Cook began the first courses in physical culture for the male students in 1911; these courses were required of all students. Pictured here are two photographs of students performing gymnastic stunts, and building pyramids, using wands for balance. Cook is pictured on the second row, far right in the photo on the left.

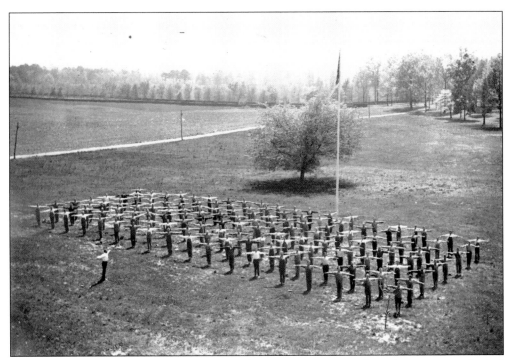

PHYSICAL DRILLS AND CALISTHENICS. Both men and women were required to take courses in physical culture from the earliest years of the school. In the top photo Cook is shown leading calisthenic exercises for the male students in the field in front of the Recitation Hall (later to be named the Administration Building and then the Hoge Building). At the girls' school, women are shown performing physical exercise on May Day 1913, in the photograph below.

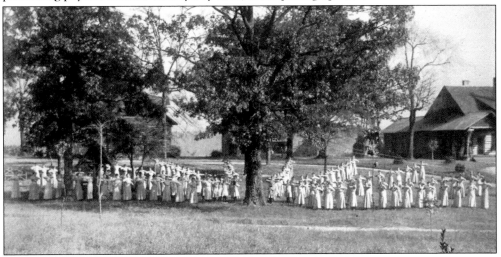

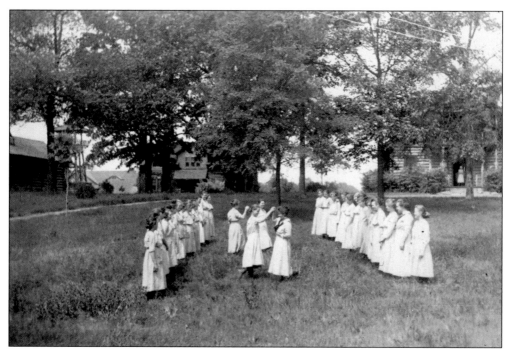

DANCING AT THE GIRLS' SCHOOL, 1917. In addition to moderate forms of exercise, programs of physical culture of the early 20th century included dance. Women are captured dancing out of doors at the girls' school in the photograph above.

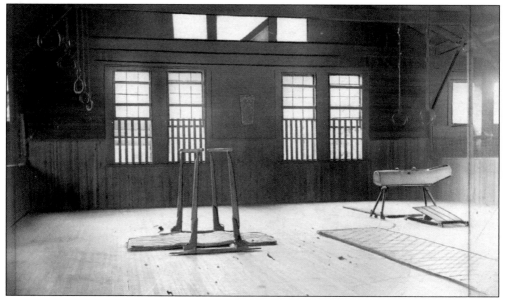

PENTECOST GYMNASIUM. Pictured above is the first gym that was built on the campus near the Recitation Hall in 1911. The students raised $500 of the total cost of $1,000. It was named for Percy M. Pentecost, a member of the senior class and an athlete who led the fund-raising efforts for the cost of the gym. The gym was furnished with rings, horse (for vaulting), and parallel bars. Here, the students received instruction in physical culture from Cook and also used the gym for practicing and playing basketball games.

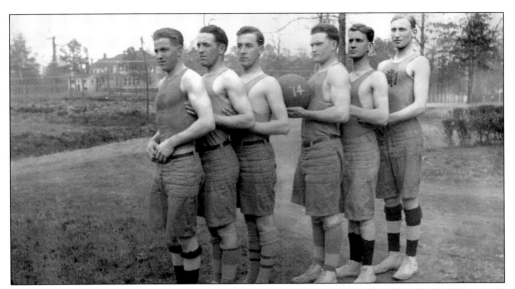

BASKETBALL TEAM, 1914. Pictured above is one of the earliest teams at the school, which lost only one game in the season, defeating Hearn Academy of Cave Spring, Georgia, and Darlington School of Rome, Georgia. Pictured from left to right are Claude Anderson (forward), Howard Pasley (guard), Benson Langley (guard), Charles Whiteside (forward), Clay Kenemer (center), and Clifton Russell (guard).

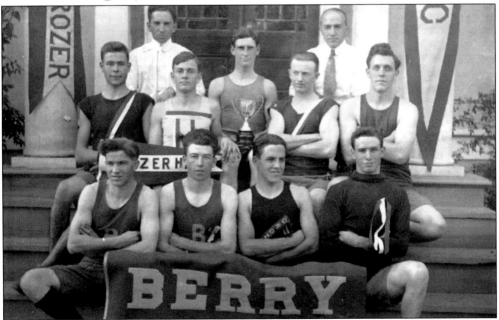

CROZER WINS INTER-DORMITORY TRACK CHAMPIONSHIP, 1914. Inter-dormitory competitions in baseball, basketball, cross-country, and track began in the early years of the school. Shown here is the track team of Crozer Hall that won the Trophy Cup and the Track Pennant in 1914. Mr. Collier and Mr. Davis, faculty representatives, are seated on the back row behind the team. Members of the team, from left to right, are (first row) Claude Anderson, Homer Hardman, Mitchell Nunn, and Burton Massey; (second row) Paul Henson, William Dobson, Watson Kenemer, Bascom Sorrels, and Burton Skelton.

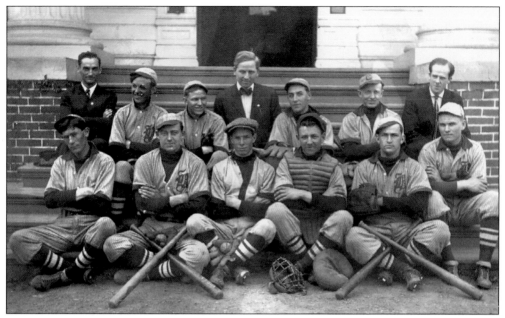

BASEBALL TEAM, 1915. Cook is pictured here with the 1915 baseball team and Mr. Liggett (far left, back row), who helped coach the team. Members of the team, from left to right, are (front row) Wood (left field), James Howell, Massey (pitcher), McEntyre (catcher), Forrester, and James Hobart Whitaker (third base); (back row) Mr. Liggett, Philyaw (second base), R. Claude Anderson (first base), Mr. D.E. Harrison, W. Benson Langley (center field), George Bascom Sorrels (right field), and Prof. S.H. Cook.

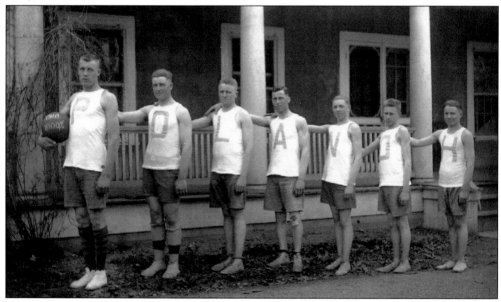

INTER-DORMITORY BASKETBALL CHAMPIONS, 1918. In 1918, Poland Hall defeated Crozer and Emery Halls, winning every game of the series to claim the basketball pennant from Crozer Hall, which had won the pennant every year since the school had held competitions. Pictured from left to right are Fred Roberts, Bradford Hamrich, Vernon Marks, John Ferguson, two unidentified, and Donald Gunn.

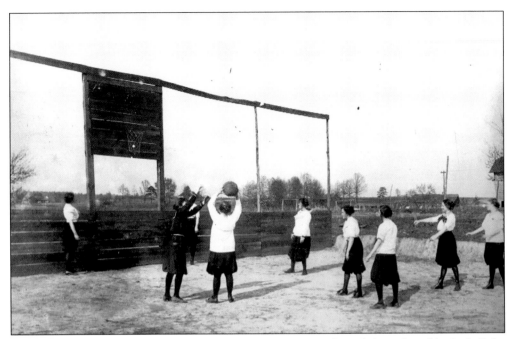

WOMEN'S BASKETBALL GAME, 1914. In 1883, Senda Berenson adapted the rules of basketball for women and her students at Smith College played the first basketball game. In the late 19th and early 20th centuries, basketball became a very popular sport for female students at colleges. Berry students are shown playing on an outdoor court dressed in bloomers, which were the typical costume for exercise and sports in this era.

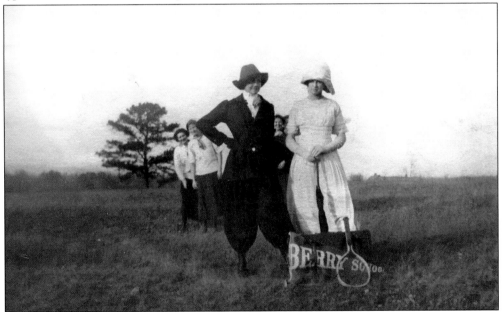

TENNIS AT BERRY, 1914. In 1915, female students at the school expressed a desire for their own tennis court. Until Cook and some of the boys built a court at the girls' school in the early 1920s, the women played on the court at the boys' school. Pictured here are several women, attired in the fashion of the day with tennis racket and a Berry Schools' pennant.

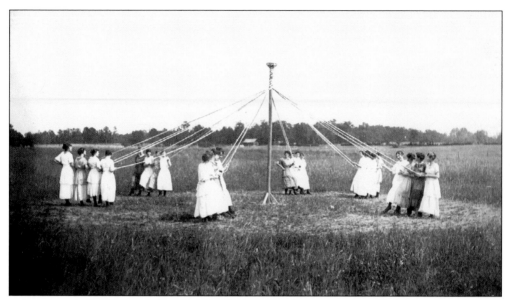

MAYPOLE DANCE, 1916. For many years the Maypole dance was a part of early Field Day celebrations at the girls' school and continued to be a tradition well into the 1950s. Pictured above is one of the first celebrations.

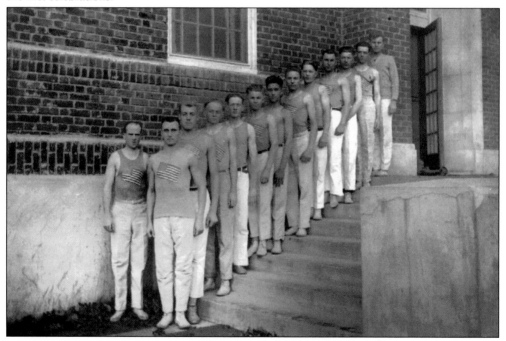

GYM TEAM, 1918. Samuel Henry Cook, director of physical culture, chose the best students from his classes to form the gym team, which gave exhibitions at special events on campus. The program of these exhibitions consisted of high pyramids, work on the horse, parallel bars, and stunts on mats. Pictured above are members of the 1918 team dressed in gymnastic attire with the American flag displayed on their shirts. From left to right are S.H. Cook (director), Allen Pettigrew, Fred Roberts, Jack Perry DeShazo, Tucker, Pebble Ballard (leader), Weldon, Robert Griffits, Shepard, Hamby, Wills, Robertson, and Lester Seay (leader).

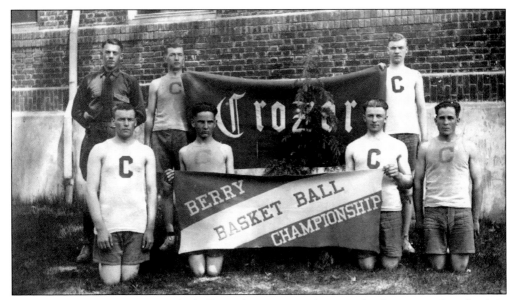

BASKETBALL CHAMPIONS, 1919. Basketball was the most popular sport for the men at the school. In the autumn, a series of 12 games was played for the pennant. From those teams, the varsity team was selected for the spring season. Pictured above are members of Crozer Hall's inter-dormitory basketball team that won the championship in 1919. Pictured from left to right are (front row) Grover Ford, Gunn, Charlie Hamrick, and Carlton Colquitt; (back row) Birchie Romefelt, Lucius Langley, and Fred Fort.

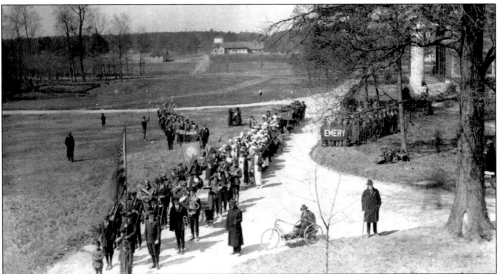

FIELD DAY, 1919. Field Day became a sporting ritual, contested annually in the autumn since its inception in 1907. According to the early traditions, the high school boys and girls assembled near the boys' dining hall for the celebration. The band played music, and the student body, followed by the queen and her attendants, who represented the dormitories, marched in the morning to the athletic field. The students divided into three groups, each carrying a banner that represented Crozer, Emery, or Poland dormitory. After the crowning of the queen, an address was given, and the contests in track and field events began. Pictured above is the beginning of the program with the procession lined up in front of the Recitation Hall.

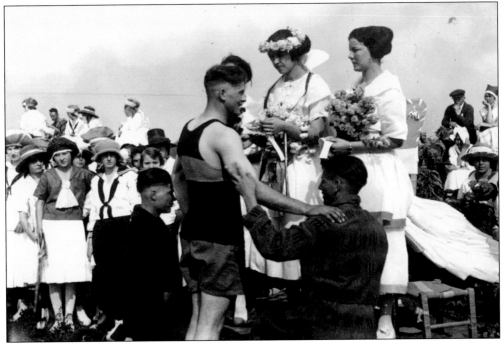

CROWNING THE VICTOR, 1922. Pictured above is the crowning of Miller Hamrick, who received the honor for Emery Hall, from Eva Mae Green, the Field Day queen. Elsie Williams is the attendant on the right. From 1921 to 1927, Emery won seven consecutive Field Days.

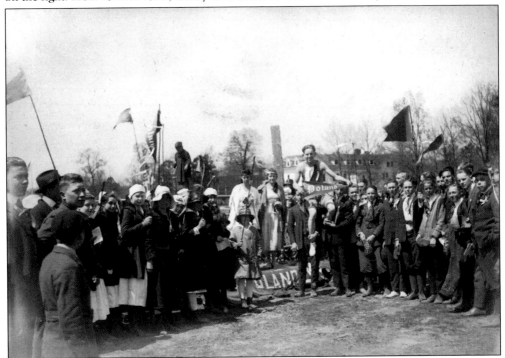

POLAND WINS FIELD DAY, 1918. A member of the Poland team is hoisted on the shoulders of some of the spectators as Poland Hall wins Field Day in 1918.

ELIZABETH LANIER BOLLING TEACHING FOLK GAMES TO STUDENTS. Pictured above is Elizabeth Lanier Bolling, the granddaughter of Georgia Poet Laureate Sydney Lanier, teaching dances and folk games to the students of the school. She came to the school to teach the colonial traditions in dance and folk games in February 1921, and was one of many distinguished guests of the school.

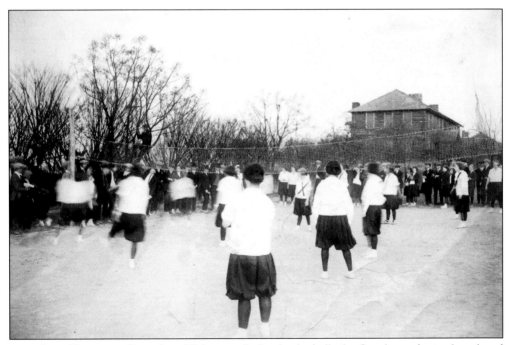

INTER-CLASS VOLLEYBALL GAME. In addition to playing basketball, the female students also played inter-class volleyball games. They are shown here in the early 1920s playing volleyball on an outside court at the girls' school. In this competition, the class of 1923 defeated the class of 1924. The victors are pictured on the cover of this book.

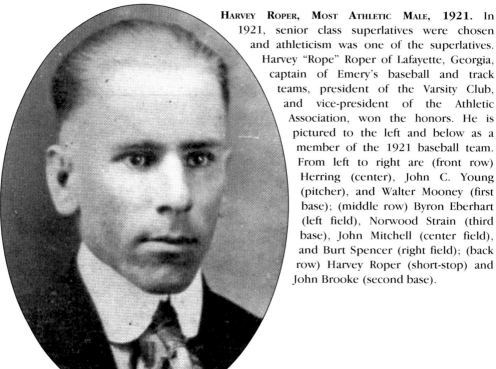

HARVEY ROPER, MOST ATHLETIC MALE, 1921. In 1921, senior class superlatives were chosen and athleticism was one of the superlatives. Harvey "Rope" Roper of Lafayette, Georgia, captain of Emery's baseball and track teams, president of the Varsity Club, and vice-president of the Athletic Association, won the honors. He is pictured to the left and below as a member of the 1921 baseball team. From left to right are (front row) Herring (center), John C. Young (pitcher), and Walter Mooney (first base); (middle row) Byron Eberhart (left field), Norwood Strain (third base), John Mitchell (center field), and Burt Spencer (right field); (back row) Harvey Roper (short-stop) and John Brooke (second base).

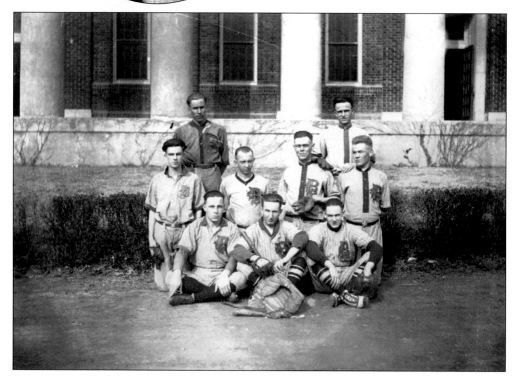

FRANCES TATE, MOST ATHLETIC FEMALE, 1921. Frances "Tater" Tate of South Georgia won the most athletic female superlative. She was secretary of the Delphic Literary Society, yell leader for Delphics, and chairman of the Athletic Committee, which was formed in 1914 to promote sports for female students.

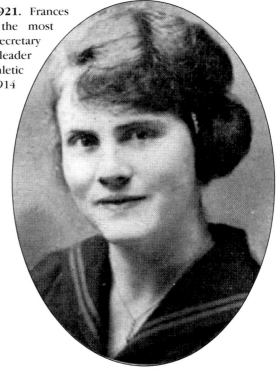

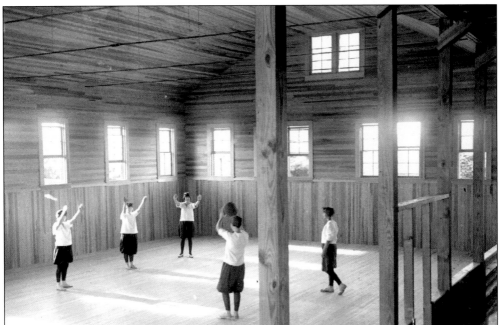

ALUMNI GYMNASIUM FOR FEMALE STUDENTS. Pictured above is the first gymnasium that was built at the girls' school. Early in 1921, Martha Berry expressed an interest in building a gymnasium for girls so the students would have proper exercise and better health. A gymnasium was added to High Cottage, a dormitory for girls that was given by Mrs. High of Atlanta, founder of the High Museum in Atlanta. In the photograph above, several girls are shown engaged in passing drills.

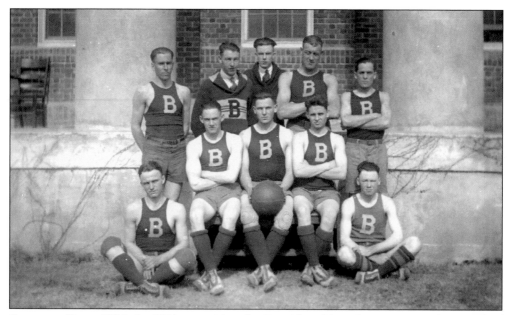

BASKETBALL TEAM, 1921. In 1921, a petition for "outside athletics" was sent to the Board of Trustees to resume competitions with other schools after the board banned those competitions in 1919. Permission was granted and the "Silver and the Blue," as the basketball team came to be known, began its season in Piedmont, Alabama, against the YMCA team. The season also included competitions with Cave Springs, the State Normal School of Jacksonville, Alabama, and Darlington, an old rival. During the 1920–1921 season, the Berry team won the State Prep School Championship, which included teams from Piedmont, Darlington, and Oglethorpe. Berry also began competition with other schools in track and baseball. Team members, from left to right, are (front row) John Brooke (guard) and Troy Evitt (forward); (middle row) Walter Mooney (guard) and Luther Wyatt (forward), and Walter Johnson Murray (forward); (back row) Harvey Roper (forward), E.M. Clemenson (coach), Byron Eberhardt (manager), Fred Roberts (center), and Carlton Colquitt (guard).

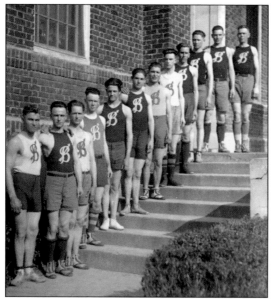

TRACK TEAM, 1921. In the picture to the left is the track team of 1921. From left to right are Martis Ballard (relay), John Brooke (relay), Lundy (relay), Troy Evitt (880-yard dash), Morrow (relay), Dorough (relay), Byron Eberhart (hurdle), Harvey Roper (440-yard dash, 100-yard dash, 50-yard dash, and relay), Horton (one-half mile run), Luther Wyatt (hammer), Mitchell (relay), and Roberts (shot). Roper set the 400-yard dash record of 54 seconds in 1920. Wyatt set the record for the 12-pound hammer of 130 feet, 2 inches in 1920. Fred Roberts set the record of 47 feet, 1 inch for the 12-pound shot in 1920.

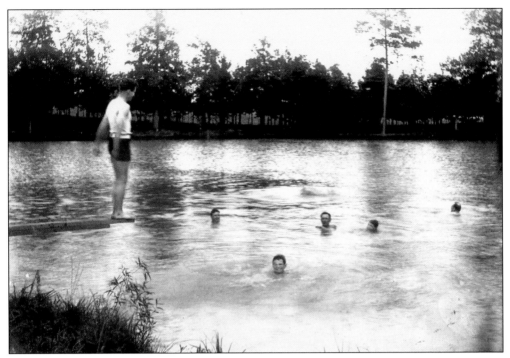

SWIMMING AT VICTORY LAKE. For years, students swam in the Oostanaula River. In 1921, the school built Victory Lake on the campus northwest of the girls' school. It became a place for recreational swimming, leisure outings, and Mountain Day swimming contests.

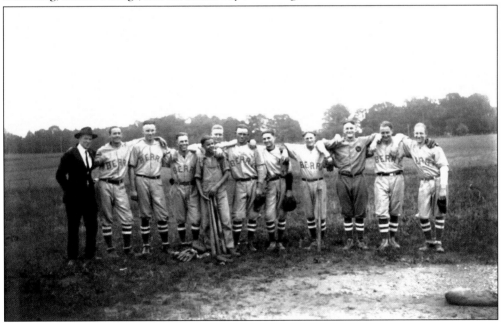

BASEBALL TEAM, 1922. Pictured above is Sam Cook with the varsity baseball team of 1922. Members of the team, from left to right, are S.H. Cook (coach), James Carl Parmenter, Herman A. Watson, Judson Moody, Marshall Levie (captain), John A. Baker, Walter Johnson Murray, Ralph Ambrose, Scoggin, Linton Deck, Ewell M. Davies, and LeRoy Young (mascot).

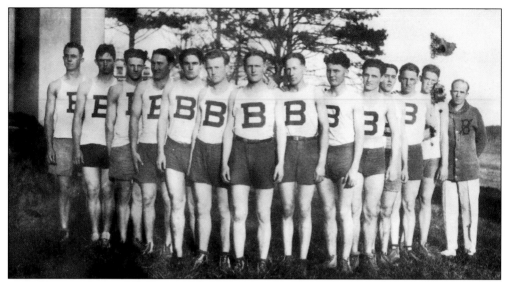

VICTORIOUS TRACK TEAM, 1924. Samuel Henry Cook had been a track athlete at Davidson College. He began to develop a running program at Berry in addition to programs in gymnastics, basketball, and baseball. He is shown above with his team. Pictured below is the school's victorious relay team. In October 1924, the team competed in the junior college division and emerged victorious, defeating athletes from Soddy, McCallie, and Baylor (prep schools), as well as the University of Chattanooga. These and subsequent victories began a long-standing tradition of excellence carried on by the track and cross-country teams of the 1960s and 1970s that was continued by the excellent women's and men's cross-country teams of the Centennial Year.

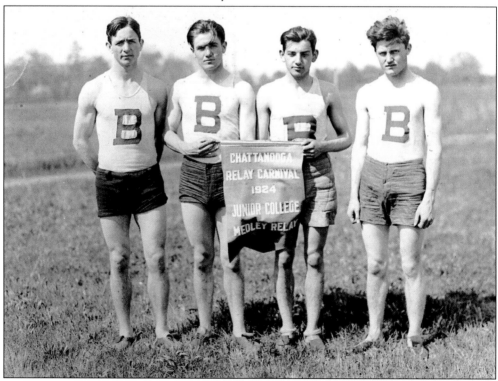

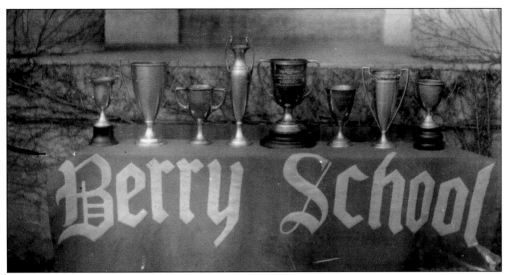

BERRY TROPHY CUPS. Pictured above are the trophy cups, many of which were won by the track team in the first two decades of the 20th century. From left to right are the Anna E. Lawrence Cup, the Hardy Cup, the "Volunteer Life" Cup, the 1922 Cup, the Etheridge Team Trophy Cup, the Chattanooga News Cup, the Ballard Cross Country Cup, and the Lovingood Cup. Charles J. Lovingood donated the Lovingood Cup in 1910 to be presented to the dormitory that earned the best record in field events during the annual Field Day. The Volunteer Life Insurance Cup was given to the team that won the most points in the one-mile run in Chattanooga and the Richard Hardy Trophy was given to the team that won the meet in Chattanooga. The Chattanooga News Cup was given to the winner of the two-mile race.

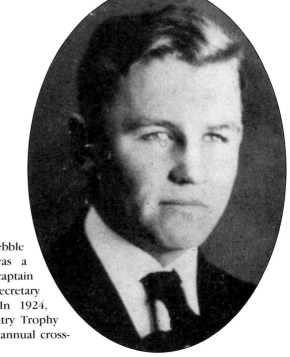

PEBBLE BALLARD DONATES TROPHY. Pebble Ballard of Forrest Park, Georgia, was a member of Emery's basketball team, captain of the cross-country team, and secretary and treasurer of the Varsity Club. In 1924, "Peb" donated the Ballard Cross-Country Trophy to be given to honor the victor of the annual cross-country race.

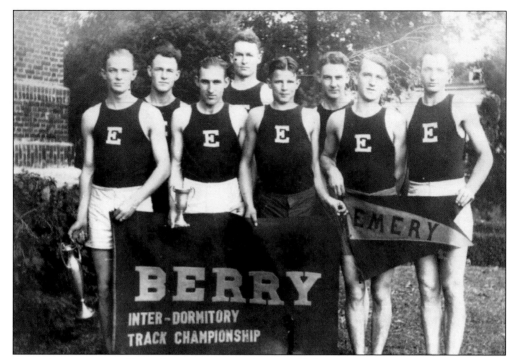

EMERY INTER-DORMITORY TRACK CHAMPIONS OF 1925. Pictured above are members of the Emery track team. They are, from left to right, H. Dobson, Wilbur D. Jones, Frank Moore, Heath Whittle, Carl T. Bedwell, John C. Anderson, August Kokal, and Emrys Johns.

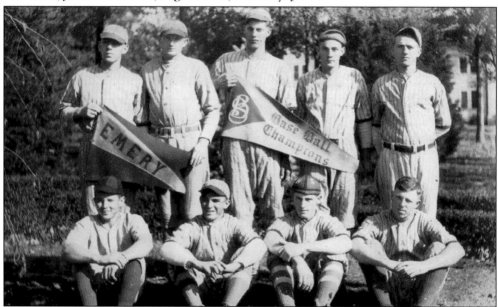

BASEBALL CHAMPIONS, 1925. Pictured above are members of the Emery baseball team, which won the 1925 inter-dormitory championship. Berry also fielded an intercollegiate team that competed with other schools in the area. Pictured here, from left to right, are (front row) John C. Anderson, Steven Vanlandingham, Clifford Evans, and Williams (Hot Shot); (back row) Joe C. Hall, Emrys Johns, B. Dillard, Strawn, and August Kokal.

36

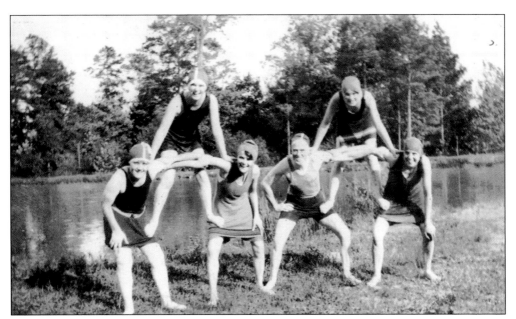

FROLICKING AT VICTORY LAKE. After Victory Lake was built in 1921, it became the site of many recreational outings and celebrations of the school. Samuel Henry Cook is shown in the photo above with several of the female students performing a gymnastic stunt. From left to right are Katherine Banks, Alice Hulme, Monica Henderson, S.H. Cook, Anna Carter, and Caroline Banks.

THE BASKETEERS OF 1925. From 1919 to 1925 Berry competed with other schools in basketball, baseball, and track until the trustees banned these competitions. In 1925, the basketball team was very successful, defeating Alabama State Normal School (for the first time on their home court), Darlington, a team from DeKalb County, and one from Tallapoosa, Georgia. The team also entered the Cotton States Tournament in Auburn, Alabama, marking the first tournament competition for the school. Team members, from left to right, are Carl Sturdevant (guard), Emrys Johns (forward), Alton Tollerson (guard), K. Anderson (center), John Holcomb (forward), Joe Lovvorn (guard), Heath Whittle (forward), and James Sturdevant (forward).

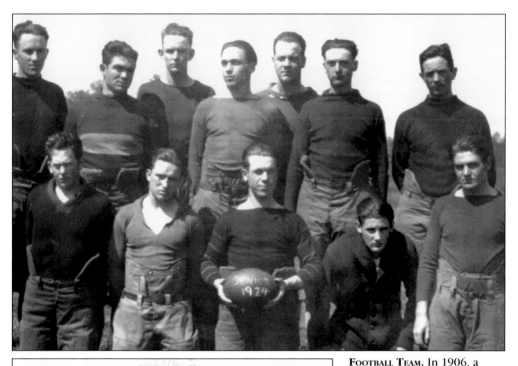

THE BERRY SCHOOLS

MARTHA BERRY, Founder and Director

INCORPORATED

ESTABLISHED 1902

A CHRISTIAN INDUSTRIAL SCHOOL FOR

COUNTRY BOYS AND GIRLS

EXPRESS AND TELEGRAPH OFFICE ROME, GEORGIA

MOUNT BERRY, GEORGIA

November 12, 1925

Messrs. Green, Hoge, & Keown,
Executive Committee, Berry Schools,
Mount Berry, Georgia

Dear Sirs:-

Will you please see that no games of baseball are played with outside teams, or games of any kind played with teams outside of the schools.

I notice the boys are practicing football on the outskirts of the girls' campus. Please have them understand that they are not to practice any games off the boys' campus,

Faithfully yours,

Martha Berry

FOOTBALL TEAM. In 1906, a student-formed football team at the school began competing against other schools in the area; however, soon thereafter the school no longer allowed football to be played. Martha Berry was opposed to football, arguing that it, along with other new cultural experiments such as jazz, had negative effects upon scholastic ideals. Shown to the left is a letter that Berry wrote to members of the executive committee of the school prohibiting boys from practicing football and banning competitive sport with other schools. Pictured above is a student-formed football team in 1924 that was probably practicing on the fields near the girls' school.

A Chronology of Selected Events in the History of Sport at Berry College from 1902 - 1945

1902
- January 13, Boys' Industrial School is founded.
- November 16, Young Men's Christian Association (Y.M.C.A.) of Berry, which will sponsor many of the early sports contests, is organized.

1904
- Berry enters athletic competition with other schools in baseball and defeats a team from Trion and Hearn Academy of Cave Spring, Georgia.

1905
- Students build the first baseball field on the campus.

1906
- October 6, dormitory baseball teams are organized for Brewster, Glenwood, and Inman Halls and the Cottages, and the first dormitory baseball series begins.
- Fall term, a student-formed football team competes against State Mutual Life Insurance Team, East Rome High School, and other teams in the area.

1907
- June 14-23, Berry boys compete in track and field events for the first time against other schools (Emory College and Ga. Tech) at a Y.M.C.A. - sponsored conference near Ashville, N.C.
- Fall term, the Athletic Association is formed.
- October 21, the first Field Day is contested under the auspices of the Student Men's Christian Association
- First interscholastic basketball team is formed.

1908
- Corporate charter is amended with the legal name changed to "The Berry School."
- Students build a quarter-mile track and an outdoor basketball court.

1909
- First basketball game is held with other schools.
- The Martha Berry School for Girls opens on Thanksgiving Day.

1909/1910
- Baseball, basketball, and football teams are organized, and a series of inter-dormitory games is played in season.

1910
- March 18, the Young Women's Christian Association is formed.
- October 7, Mr. Charles J. Lovingood donates silver cup to be presented to the dormitory making the best record in field events during the annual field day.
- August, Mr. Samuel Henry Cook is hired as head of the Department of Mathematics, teacher of physical culture, and athletic director.

1911
- First gym, Pentecost Gymnasium, named after senior Percy M. Pentecost, opens on Thanksgiving Day.

1913
- Ty Cobb and his All-Stars defeat the Berry team in a fund-raising game on the campus.

1913/1914
- First Athletic Committee, comprised of faculty and staff, is formed.

1914
- Women's Athletic Association is formed.
- October 7, the first Mountain Day is held to honor Martha Berry's birthday; sports contests become a part of the annual celebration.

1915
- Coach Charles H. Warren's track team competes at Inter-Collegiate Athletic contests in Atlanta.

1916
- Dr. Cook organizes the Varsity Club.
- Miss Ellis is hired as the first instructor of physical culture for the female students.

1917
- Trustees ban interscholastic athletic competition for the first time; competition resumes two years later.

A Chronology of Selected Events in the History of Sport at Berry College from 1902 - 1945

continued

1920
- Alumni Gymnasium is added onto High Cottage, and the female students have their first gym.

1921
- Emery Hall wins the first of seven consecutive field days.
- First annual Field Day is held for female students on Thanksgiving Day.
- Men's basketball team, the "Silver and the Blue," ends the season with an 8-1 record and defeats the Coosa Y.M.C.A. of Piedmont, Alabama; Darlington School in Rome; and Oglethorpe to win the State Prep School Championship.

1924
- December 6, Pebble Ballard, class of 1921, donates the Ballard Cross-Country Trophy to honor the victor in the annual cross-country race.
- Men's relay teams win the medley and two-mile relay at Chattanooga Relays, the first major victory for a Berry team.

1925
- February 25, the basketball team enters its first tournament, the Cotton States Tournament in Auburn, Alabama; and this marks the first tournament competition for the school.
- Board of Trustees rules out athletics for the second time, and the ban lasts for two years.
- December, St. Martin's Protestant Episcopal Church of Radnor, PA, donates a Girl's Field Day Trophy.

1926
- February 20, Charles Paddock, world-famous sprinter and member of the American Olympic Team, delivers a speech to the students at the college about how to run.

1927
- Women's class basketball series begins; it is a round-robin tournament and the first of such competitions for women at the school.

1928
- Fielding Yost, director of athletics at the University of Michigan, gives a lecture about the value of sport on campus.
- March 11, track team takes second place at the Tennessee Interscholastic Athletic Association Meet in Nashville.

1929
- Maud Allen McDonald, director of art and physical culture and member of the Athletics Committee, donates a trophy in her name for the winner of the annual Thanksgiving Day Field Day for Girls.
- Sprint medley team of Beck, Barnett, Bagley, and Crane set a new record at the Southern Relays at Ga. Tech, and six men on the track team set new records at the Dixie Meet in Chattanooga.

1931
- Ford Gymnasium is built.
- Syrreb and Georgian coeducational literary societies, which will later form the structure for intramural competition, replace the Delphic and Athenian Societies.

1937
- Using bricks made at the Berry kiln, students construct Memorial Gymnasium.

1945
- April 2, the first Annual Play Day is held for the female students.
- November 30, a basketball team coached by John Warr, resumes intercollegiate competition for the first time in ten years.

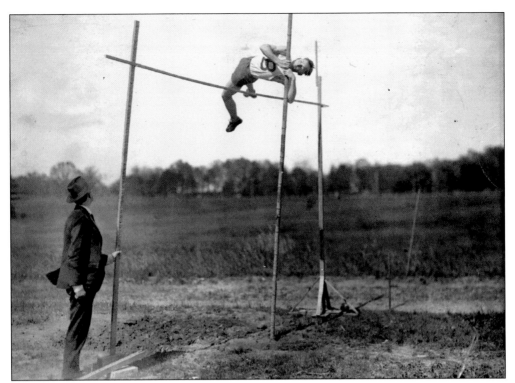

CARL STURDEVANT, CHAMPION POLE VAULTER. In the photograph above, Carl Sturdevant pole vaults while Coach Samuel Henry Cook stands by and steadies the bar. In 1924, Sturdevant set the record of ten feet and three inches, a record that stood for four years and was broken with a vault of ten feet, nine inches by John Mann.

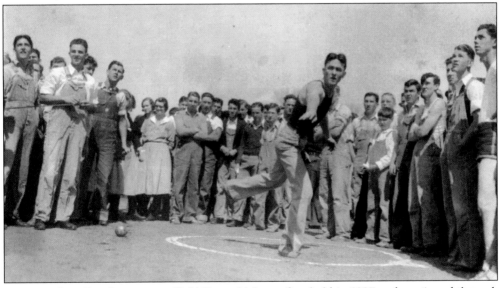

FIELD DAY SHOT PUT COMPETITION. Field Day, which was first held in 1907 and continued through the mid-1960s, included both track and field events. Field events included the 12-pound hammer, the 12-pound shot, and the high and broad jumps. The shot is being thrown in the photo above.

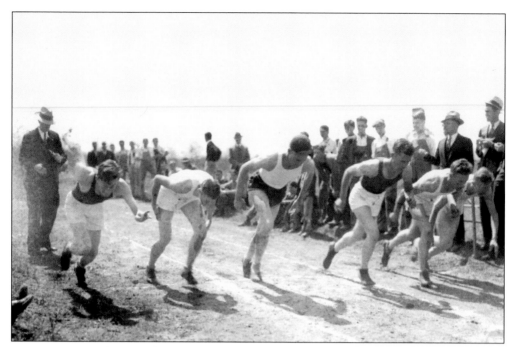

FIELD DAY RACE. When Field Day was first held, the running events included were the 50-yard dash, the 100-yard dash, the 220-yard dash, and the one- and two-mile runs. Here, in the 1920s, Samuel Henry Cook is shown starting one of the races.

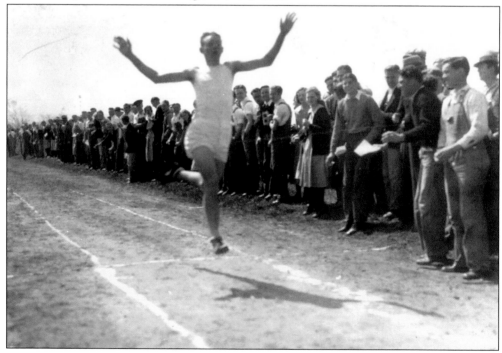

FIELD DAY RUNNING BROAD JUMP. As early as 1909, the running broad jump was contested as part of the annual Field Day. Pictured above is an athlete in the middle of the jump as spectators line the pit.

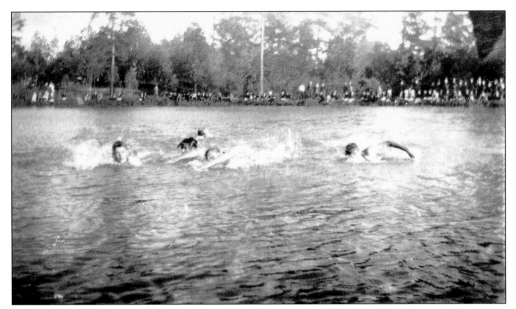

FIFTY-YARD SWIM ON MOUNTAIN DAY. On October 7, 1914, the first Mountain Day was celebrated to honor Martha Berry's birthday. Sports contests soon became a part of the celebration. Shown above is the 50-yard swim in Victory Lake on Mountain Day, 1926.

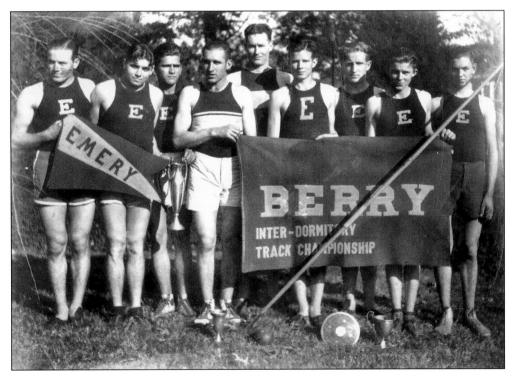

FIELD DAY CHAMPIONS, 1926. Pictured above are the members of the Track Championship Team from Emery Hall. From left to right are Lloyd Fletcher, Jones, Mack Crumm, James O. Kelly, Carver, Carl T. Bedwell, John C. Anderson, Mann, and Lloyd Lacy.

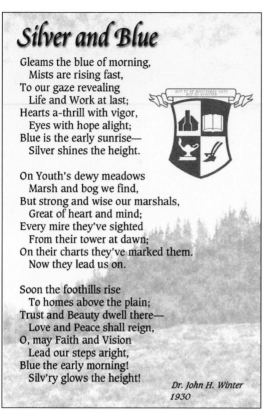

Silver and Blue

Gleams the blue of morning,
 Mists are rising fast,
To our gaze revealing
 Life and Work at last;
Hearts a-thrill with vigor,
 Eyes with hope alight;
Blue is the early sunrise—
 Silver shines the height.

On Youth's dewy meadows
 Marsh and bog we find,
But strong and wise our marshals,
 Great of heart and mind;
Every mire they've sighted
 From their tower at dawn;
On their charts they've marked them.
 Now they lead us on.

Soon the foothills rise
 To homes above the plain;
Trust and Beauty dwell there—
 Love and Peace shall reign,
O, may Faith and Vision
 Lead our steps aright,
Blue the early morning!
 Silv'ry glows the height!

Dr. John H. Winter
1930

CLASS SONG—"SILVER AND BLUE". Shown to the left is the school song that was written by Dr. John H. Winter in 1930. Winter was a professor of sociology and also dean of men at the school from 1930 to 1935.

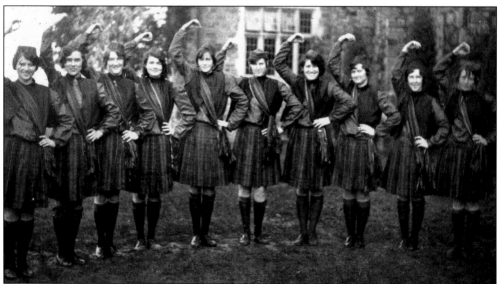

HIGH SCHOOL JUNIORS DANCE THE HIGHLAND FLING, 1930. Under the direction of Miss Maude McDonald, the program of physical education expanded to include basketball, volleyball, dancing, and gymnastics. Basketball and dance were the most popular. Shown here are members of the junior class dancing the Highland Fling. From left to right are Masina Hicks, Dorothy Hammond, Virginia Lockman, Christing Rahn, Irene Leary, Geneva Craig, Lois Ray, Nina Fletcher, Margaret Davis, and Helen Langston.

GARLAND C. BAGLEY—CHAMPION ATHLETE. In April 1929, Berry shattered the relay record at the Tech relays in Atlanta. Composed of Lawrence Barnett, Garland Bagley, John Crane, and Sereno Beck, the sprint medley team clocked a 3-minute, 42.2-second race, breaking the record set by Boys High of Atlanta by 13.8 seconds. On Field Day in December 1929, Garland Bagley, a versatile athlete from Cumming, Georgia, won five first-place ribbons to lead Lemley Hall to victory—the 20-yard dash, the 100-yard dash, the 220-yard dash, the 120-yard hurdles, and the discus throw. Pictured below are Bagley's track records in 1930. His 100-yard dash record was not broken until 1934.

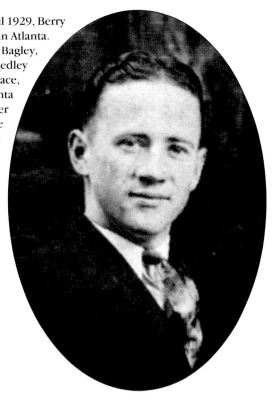

BERRY COLLEGE 1930 TRACK RECORDS

Events	Holder	Record	Year
50-yard dash	Garland Bagley	5 2.5 seconds	1929
100-yard dash	Garland Bagley	10 1.5 seconds	1928
220-yard dash	Garland Bagley	22.7 seconds	1930
440-yard dash	Lawrence Barnett	52 1.5 seconds	1930
Half mile run	John Crane	2 min. 00.1 seconds	1929
One mile run	Sereno Beck	4 min. 40 3.5 seconds	1927
Two mile run	Clyde Cox	10 min. 10 seconds	1920
120-yard hurdle	Heath Whittle	14 1/2 seconds	1925
Pole vault	Elease Rahn	10 feet, 9 3/4 inches	1929
Running high jump	Walter Murray	5 feet, 10 1/2 inches	1923
Running broad jump	Fielding Tanner	20 feet, 10 inches	1928
12 lb. shot	Fred Roberts	47 feet, 1 1/2 inches	1922
Cross country run	Carl Bedwell	16 minutes, 8 seconds	1927
Javelin throw	Kankakee Anderson	161 feet	1924
Discus throw	Garland Bagley	111 feet, 4 inches	1930
Half mile relay	Lemley Hall	1 minute, 36 seconds	1925

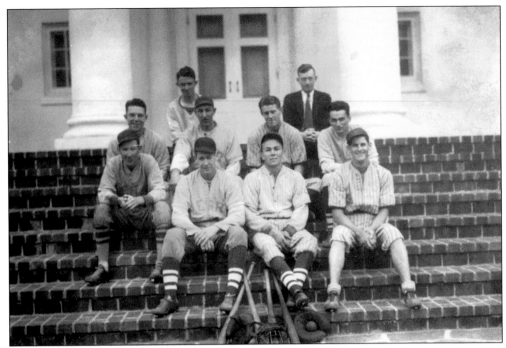

BASEBALL TEAM, 1932. Although the school did not engage in competition with other schools in the 1930s, inter-dormitory competitions continued to be held in baseball, basketball, and track and field. From these competitions, a varsity team comprised of the best players was formed. Pictured above is Coach Jesse Gudger's team. They are, from left to right, (front row) James Stamps, Preston Stamps, Sam Crisler, and Beamon Hill; (back row) Frank Jamison, Frank Strain, Asa Capps, Paul Travis, Jesse Gudger (coach), and William Keheley.

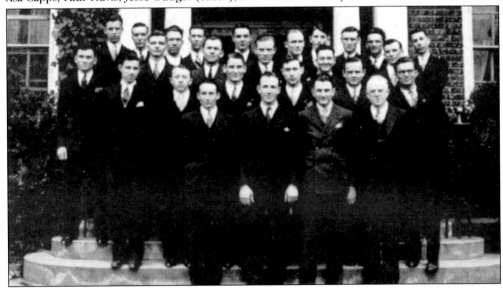

VARSITY CLUB, 1936. In 1916, Professor Cook (pictured first row, far right), organized the Varsity Club "to arouse a deeper interest in athletics so every boy will strive to win a letter and become a member of the club, which everyone should consider an honor." Pictured above are the wearers of the "B" in track, cross-country, tennis, gym, baseball, and basketball.

46

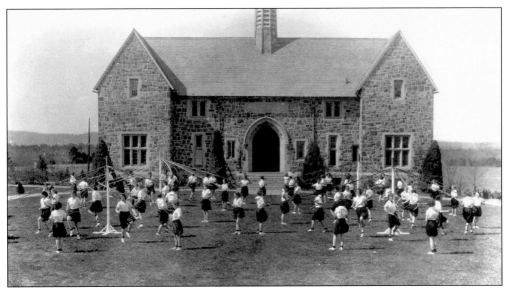

GIRLS WEAVING MAY POLES ON FIELD DAY, 1932. On Thanksgiving Day 1932, the female students are shown weaving May Poles, an activity that began in the first years of the school and was part of their Field Day for many years. In the background is Ford Gymnasium, part of the Ford buildings that were funded by Henry Ford.

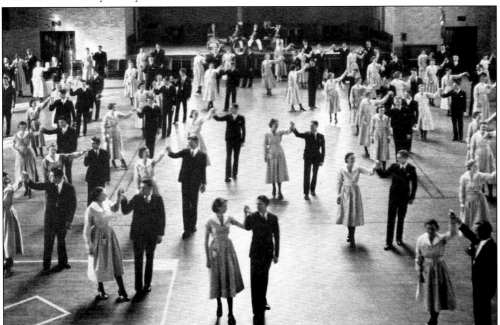

ROOSEVELT BALL IN THE FORD GYMNASIUM, 1934. Berry College has had many visitors throughout its 100-year history. In 1910, President Theodore Roosevelt came to Berry. Before his visit he urged Martha Berry to admit girls, which she did in 1909. In 1934, Berry celebrated President Franklin D. Roosevelt's birthday on January 30 in the Ford Gymnasium with a Roosevelt Ball for the benefit of the crippled children of Warm Springs, Georgia. Pictured above are the nearly 400 students who attended and contributed $25, which was sent to Mrs. James Roosevelt to present to her son, the President.

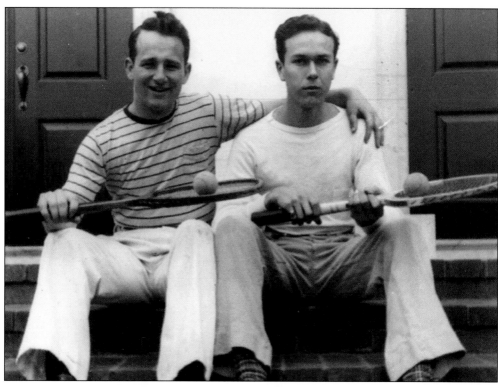

Berry Loyalty Song

We're loyal to you old Berry,
We'll never get blue old Berry,
We'll back you to stand
'Gainst the best in the land,
For we know you have sand, old Berry
 Rah! Rah!
So stand on your feet, old Berry,
Ne'er dream of defeat, old Berry,
By might we are bound to win,
We tackle each task like sin.
It's easy for you, *Old Berry.*
Fling out that dear old flag of Silver and Blue.
Lean on, your sons and daughters
fighting for you,
 Like men of old on giants placing reliance,
 shouting defiance, *os-key-wow-wow!*
Amid the rolling hills that nourish our land
For honest labor and and learning we stand,
And unto thee we pledge our heart and hand.
Dear Alma Mater, *Berry Schools.*

DOUBLES CHAMPION, 1942. Soon after he arrived at Berry, Samuel Henry Cook formed a tennis association to promote competition among the students, and an annual tennis tournament was held each year for many years. Pictured above are Thad Pirkle and Billie Bullock who won the doubles championship in tennis, which was held from the earliest years of the school.

BERRY LOYALTY SONG. To the left is the school's loyalty song, a version of the Illinois Loyalty Song, which was adopted by the school in 1911.

MEMORIAL GYMNASIUM, THANKSGIVING DAY, 1942. Memorial Gymnasium, pictured above, was constructed in 1937 with brick made at the schools. It commemorated James H. Kidder, brother of Brainerd Kidder, who died as a result of an accident in the old Pentecost Gymnasium. Students are shown above entering this gym for the annual Thanksgiving Day basketball game played by male students. It was a grand celebration at the school, with music played by the band at the game, followed by a Thanksgiving Day meal.

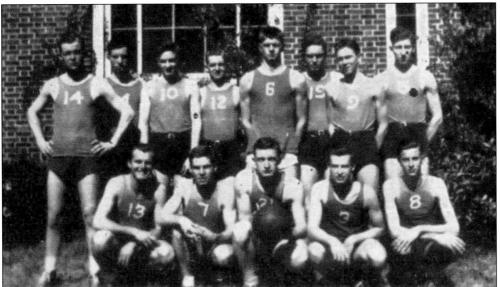

BERRY RESUMES INTERCOLLEGIATE BASKETBALL COMPETITION. In the fall of 1945, Coach-Registrar John C. Warr formed an intercollegiate basketball squad that played high school teams, independent teams, and junior college and college teams from Georgia, Tennessee, and Alabama. Berry began competition with other schools after many years during which the Board of Trustees had banned intercollegiate sport.Pictured above is the team that concluded the season with a 12-10 record. In the photograph above, from left to right, are (front row) Whiddon, Williams, Miller, Sammons, Lucas; (back row) Hester, Hawkins, Daniel, Walker, Dorton, Morris, Chapman, and Dantzler.

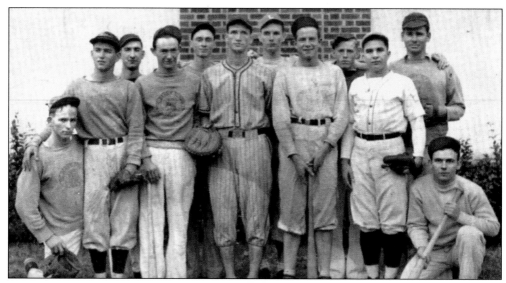

VARSITY BASEBALL TEAM, 1940. The varsity baseball team was composed of the men who were outstanding players during the fall Dormitory Series. Members of the team were awarded the varsity "B." Jesse M. Gudger coached the team and all three Dickey boys from Kelso, Tennessee—Garland, Bob, and Edward—were members of the team. Garland, the pitcher of the team, is pictured below in 1942. Team members are, from left to right, Garland Dickey (pitcher), Bob Dickey (short stop), Edward Dickey (catcher), Vance Freeman (catcher), Wayne Dozier (utility), Ralph Laster (utility), Thomas Hall (center field), Kenneth Mishoe (second base), Donald Lamb (right field), James Lowery (first base), Thomas Gandy (left field), Joe Clark (pitcher), and Earl Pendley (third base).

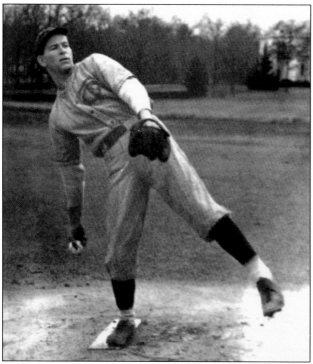

Two

Garland M. Dickey and the Re-Birth of Intercollegiate Sport 1946–1981

Far up in the hills of Georgia stands
Old Berry tried and true,
The Shrine of many a memory of
The Silver and the Blue

—Alma Mater

The Lady Vikings of Berry College paid the price and collected dividends. Coach Kay James' girls came home triumphantly Sunday afternoon from Ashland, Ohio, where they defeated four teams in as many nights to win the national women's small college basketball championship. The payoff came when the Lady Vikings disposed of West Georgia, 68-62 in Saturday night's finals. It was the 22nd time this season the Lady Vikings had gone to the winner's circle, but none equaled that one.

Coach James and her girls got back into town shortly after noon yesterday and were greeted royally. There was a parade and a reception as students gathered to welcome home their champions. Besides bringing home the title, the Lady Vikings also came back with two individual All-American honors. Both Nancy Paris and Sharon Adamson were picked on the elite team. In addition, Paris was named most valuable player in the tournament, averaging 28.8 points a game.

The triumph of the Lady Vikings in the NAIA in 1976, described above in the *Rome News-Tribune*, brought Berry College its first national championship team and its first female All-Americans. Such achievements signaled a new beginning in the Viking tradition, competition at the national level, an intercollegiate athletic program for women, and the college's first All-American female athletes.

The character of the men's program was formed by Garland M. Dickey, who returned to his alma mater in 1946 to become the first full-time athletic director of the college. With his brother, Edward, also a graduate of Berry, they launched an intercollegiate program in basketball and, with a "limited schedule of interscholastic athletics," they brought about the re-birth of intercollegiate

51

sport at the college. The Dickey brothers coached the "Blue Jackets," as the basketball team was called, until 1953. Garland became the coach of the baseball team that was added in the spring of 1947 and the track team, which was added in 1950.

Dickey added another very important dimension to the sports program—that of conference competition. In 1958, he met with several other representatives of small schools to form the Georgia Intercollegiate Athletic Conference. After joining the conference, the program of athletics for men expanded with the addition of tennis, cross-country, golf, soccer, and volleyball. Dickey also added another dimension to the sports program of the college. In 1962, he held a contest on campus to give the program a name. When the competition ended, the "Blue Jackets," initially known as the "Silver and the Blue," became the "Vikings."

In addition to these changes, Dickey retained the program of intramurals that he had known as a student with a few minor changes. Inter-dormitory basketball, baseball, and track and field were held initially by dormitories and then by the Georgian and Syrreb literary societies. The annual Field Day was held until 1965. The annual Mountain Day touch football game, which began in the early 1950s, was continued as well, also contested by the literary societies. As head of the Department of Physical Education, Dickey continued the required program of physical education and added a major in physical education.

There are parallels between the men's and women's programs during this era. The intramural program for women that had been established during the early years of the school continued. There were annual play days and the annual Thanksgiving Day basketball game between the Georgians and Syrrebs. To this was added an annual round-robin basketball tournament, sponsored by the YWCA. The program of the annual play day increased to include more sports— softball, volleyball, and speedball, with less dance and gymnastics. Synchronized swimming and modern dance became new activities for female students, and in 1972, an equestrian course was added to the physical education curriculum.

The women, too, would eventually enter interscholastic competition. The transition from intramural competition to intercollegiate sport was made possible in the form of the play day with other schools. Such contests were common among college and university programs in the United States in the 1940s and 1950s when women were not allowed to participate in intercollegiate sport. In 1960 and 1961, women from Berry traveled to West Georgia and the University of Georgia to compete in these play day competitions.

With the arrival of Joanne Rowe at Berry College in 1962, the college began a program of intercollegiate sport for women. Rowe formed intercollegiate teams in volleyball and basketball that year. Under her leadership, Berry women also entered conference competition. In 1965, she organized the Southern Women's Athletic Conference with representatives from Albany State, Georgia Baptist, and Hiwassee College. In 1967, her basketball team won the Southern Women's Athletic Conference, becoming the first women's team to win a conference. In so doing, she began a winning tradition in women's basketball that led to the national championship in 1976 and continued well into the next two decades.

In the closing years of the Dickey era, the sports program met with great success. During the 1978–1979 season, the college teams won eight of ten conference championships. The women's basketball team claimed the conference, state, and area titles, and placed third in the national tournament. The track, cross-country, and women's volleyball teams captured Georgia Association of Intercollegiate Athletics for Women (GAIAW) titles. The men's soccer team won the Georgia Intercollegiate Athletic Conference (GIAC) and District-25 titles and advanced to the national tournament. The men's cross-country team advanced to the national tournament after capturing the GIAC and District 25 titles. Three men from the track team went to the national competition, while the team captured the National Association of Intercollegiate Athletics (NAIA) District-25 title.

Such were the traditions established by Garland Dickey during his 35 years as teacher, coach, and athletic director at the college. In 1981 Dickey passed away, and Bob Pearson of Berea College came to Berry as athletic director and head of the Physical Education Department.

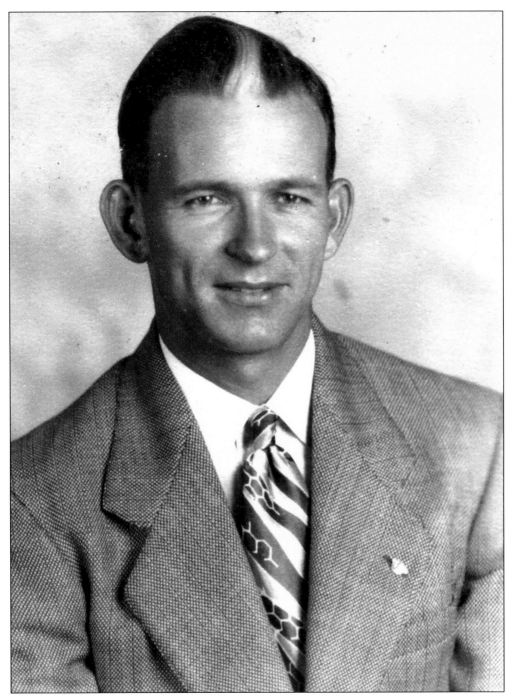

GARLAND M. DICKEY, FIRST FULL-TIME ATHLETIC DIRECTOR. In the summer of 1946, Garland Dickey, a former student and graduate of Berry, returned from the service to become the first full-time athletic director and coach of basketball and baseball. During his career, in addition to directing the athletic program, he also coached every sport in the men's program at one time or another and was the head of the Physical Education Department. He expanded the intercollegiate sports program and guided it to membership in the GIAC and the NAIA.

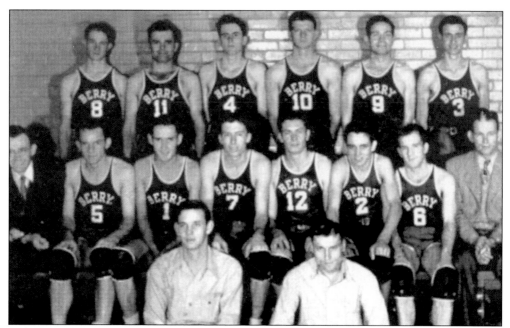

DICKEY BROTHERS COACH BASKETBALL TEAM. Edward and Garland Dickey coached basketball together for seven seasons, collaborating for 100 games as co-coaches, winning 57 and losing 43. They are shown with the team from 1947. Pictured from left to right are (front row) J.R. Murray and Edgar Pinckard; (middle row) Edward Dickey, Philip Seymour, Clifford Mizell, Raymond Bowen, Charles Strickland, Donald Wilson, Billy Brooks, and Garland Dickey; (back row) Billy Duffy, 'Dub' Douglas, Lawrence Dean, Howard Dorton, Fred Morris, and Ben Lucas.

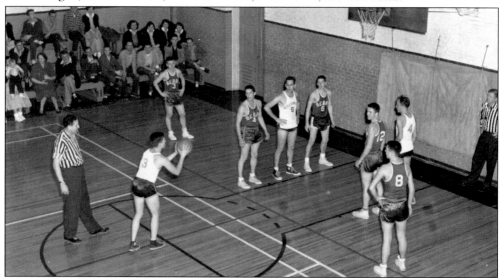

BASKETBALL GAME, MEMORIAL GYMNASIUM. In 1937, Garland Dickey was one of the students who built Memorial Gymnasium (pictured above) using bricks made in the kiln at the school. The basketball program, which featured only men's games in the 1940s and 1950s, moved its games to the Ford Gymnasium in the late 1950s. Pictured above is a game being played in the Memorial Gym (now Roy Richards Memorial Gym), the home of the "Blue Jackets," as the men's basketball team was then called.

GARLAND AND EDWARD DICKEY AFTER THEIR RETURN TO BERRY. The Dickey brothers are shown here in May 1948, outside the chapel after graduation. Together they re-established intercollegiate competition for the school, building on the foundation of the inter-dormitory competitions in which they had participated years before as students.

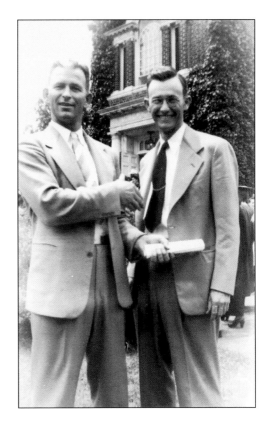

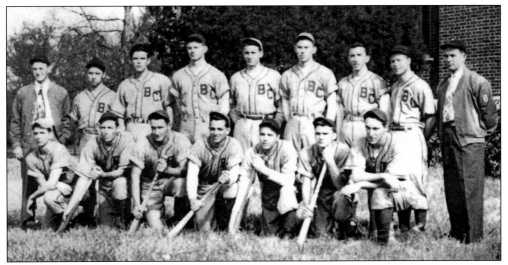

BASEBALL TEAM, 1949. Garland and Edward Dickey re-established intercollegiate baseball in 1948. The team, picked by the captains and the coaches of the two dormitory teams, consisted of nine men from Lemley and six from Thomas Berry. From left to right are (front row) John Findley, Raymond Bowen, Clifford Mizell, Donovan Wilson, Ralph Allen, Carl Welch, and Garnett Hartline; (back row) Coach Edward Dickey, Homer Kinsey, Billy Owen, Howard Dorton, Ben Lucas, George Harper, Earl Branham, Floyd Mayo, and Coach Garland Dickey.

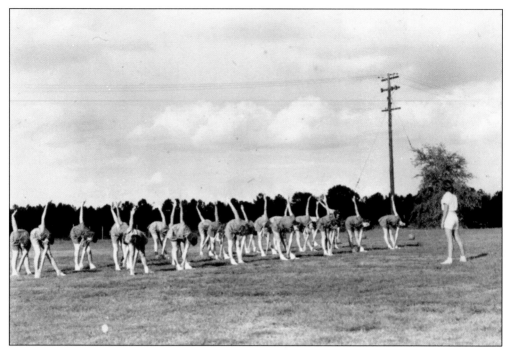

WOMEN'S PHYSICAL EDUCATION PROGRAM. In the 1950s, female students took courses in physical education, which included folk dances, relays, calisthenics, volleyball, tennis, speedball, softball, and horseshoes. They are pictured above performing calisthenics outside at the Ford Buildings.

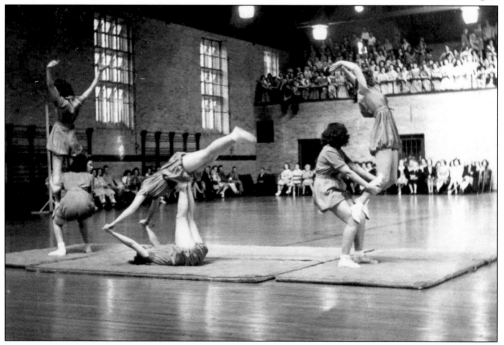

PLAY DAY GYMNASTICS EXHIBITION. In early April every year, a Play Day exhibition was given by the women's physical education classes and attended by the faculty and students. Pictured above are students performing gymnastics.

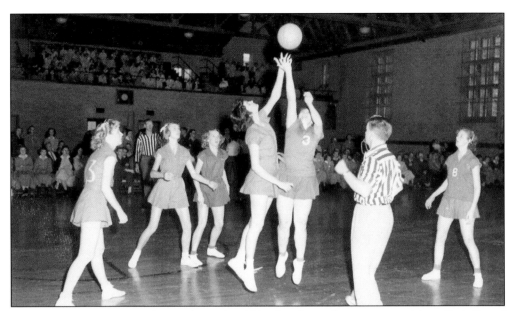

BASKETBALL TOURNAMENT, 1950. In the early 1920s, female students competed in volleyball and basketball competitions that were organized by class. Such competitions continued, later to be organized by teams representing the Georgian and Syrreb literary societies. Pictured above is the annual Georgian and Syrreb Women's basketball game played in the Ford Gym on the night before Thanksgiving in 1950.

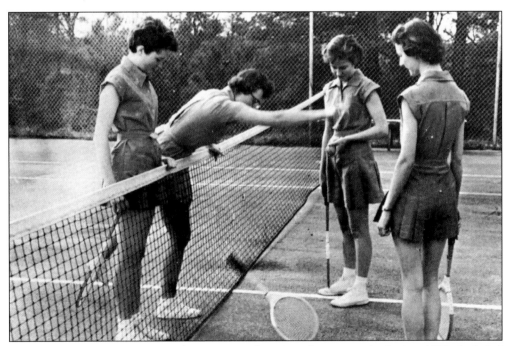

TENNIS COMPETITIONS FOR WOMEN. The program of activities for women in the late 1950s included basketball, volleyball, softball, shuffleboard, badminton, and ping-pong, in addition to tennis. In the photograph above Ann Reeves, Martha Wyatt, Ruenette Bullington, and Dorothy Everett are spinning the racket to determine who will serve first on the courts at the Ford campus.

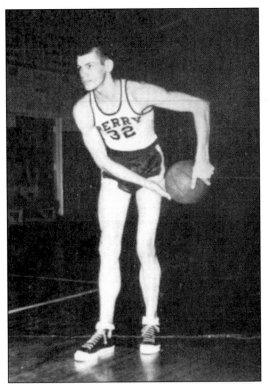

TOLBERT DEFOOR. As the intercollegiate programs expanded in the 1950s, the Berry "Blue Jackets" began to establish school records, and from these, outstanding athletes were soon identified. Pictured to the left is Tolbert Defoor, among the first of the athletes to distinguish himself. In the 1954–1955 season, he scored 14 field goals in one game. Also a baseball player, Defoor signed a professional contract with the Pittsburgh Pirates.

JOE CRAIN. Joe Crain, the 6-foot 3-inch center from Newnan, Georgia, eclipsed four school records in the 1957–1958 basketball season. He was selected as second team center on the Atlanta Journal-Constitution All-State Small College Basketball team—one of the first athletes to win such distinction. An all-around athlete, Crain set a school record by scoring 32 1/4 points in the annual Field Day in 1958.

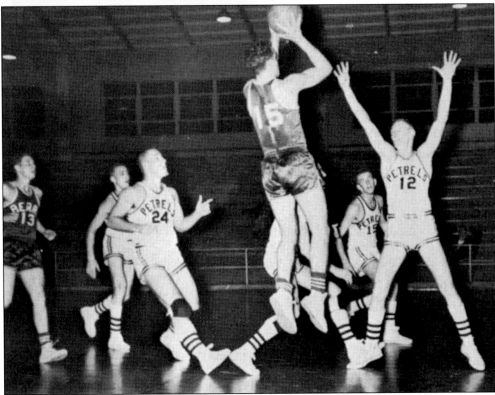

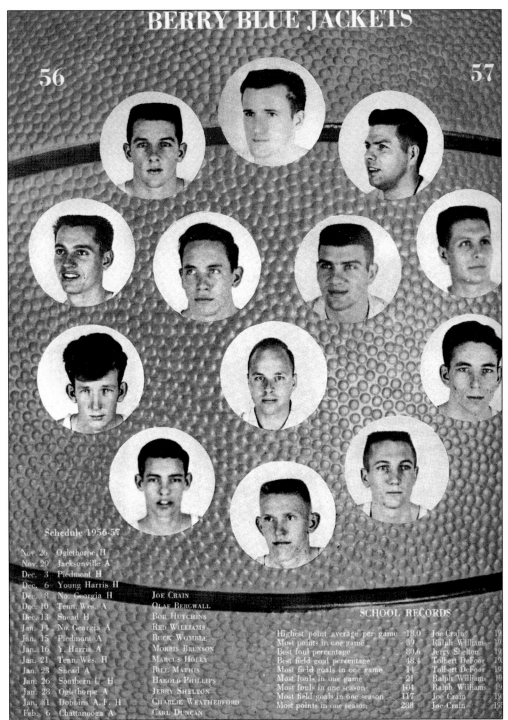

BERRY BLUE JACKETS

56 57

Schedule 1956-57

Nov. 26	Oglethorpe H
Nov. 29	Jacksonville A
Dec. 3	Piedmont H
Dec. 6	Young Harris H
Dec. 8	No. Georgia H
Dec. 10	Tenn. Wes. A
Dec. 13	Snead H
Jan. 14	No. Georgia A
Jan. 15	Piedmont A
Jan. 16	Y. Harris A
Jan. 21	Tenn. Wes. H
Jan. 23	Snead A
Jan. 26	Southern U. H
Jan. 28	Oglethorpe A
Jan. 31	Dobbins A. F. H
Feb. 6	Chattanooga A

JOE CRAIN
OLAF BERGWALL
BOB HUTCHINS
RED WILLIAMS
BUCK WOMBLE
MORRIS BRUNSON
MARCUS HOLLY
BILL MATHIS
HAROLD PHILLIPS
JERRY SHELTON
CHARLIE WEATHERFORD
CARL DUNCAN

SCHOOL RECORDS

Highest point average per game	18.0	Joe Crain 19
Most points in one game	39	Ralph Williams 19
Best foul percentage	80.6	Jerry Shelton 19
Best field goal percentage	48.4	Tolbert DeFoor 19
Most field goals in one game	14	Tolbert DeFoor 19
Most fouls in one game	21	Ralph Williams 19
Most fouls in one season	104	Ralph Williams 19
Most field goals in one season	117	Joe Crain 19
Most points in one season	288	Joe Crain 19

THE BERRY BLUE JACKETS, 1956–1957. As the basketball program continued to develop, the schedule of competitions expanded as well to include schools from Alabama and Tennessee. Shown here is the college team of 1956–1957 coached by Charles Seeger, who replaced the Dickey brothers in 1953.

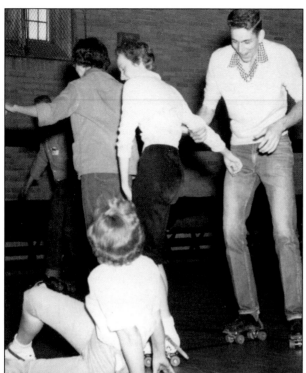

SKATING AS NEW SPORT AT BERRY. Rollerskating was introduced in 1958 as a recreational activity for students and faculty. Miss Topham, instructor of physical education for women, and Garland Dickey, head of the Department of Physical Education, sponsored the skating. Students are pictured skating in the Ford Gym. From left to right are (standing) Lucy Spillers, June Oglesby, and Coon Phillips; (seated) Jane Ward and Carroll Miller (in the background).

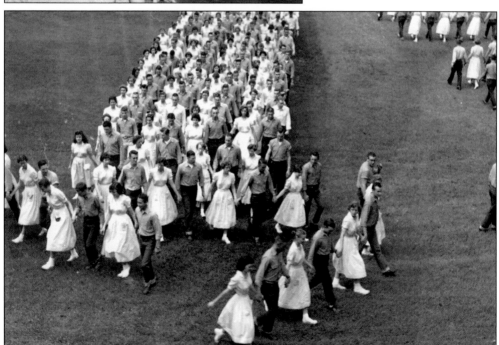

MOUNTAIN DAY, 1957. On the 50th year of the celebration of Mountain Day, students marched the first round, and gave, as a gift, one penny for each year of their age, a traditional part of the celebration. Then, as twilight gathered upon the hillsides behind them, the students lifted their voices in the singing of their loyalty song—all in celebration of the birthday of Martha Berry.

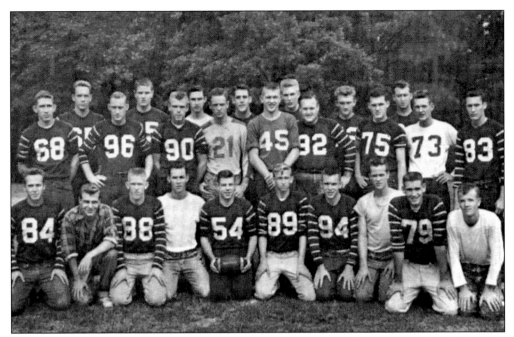

GEORGIAN AND SYRREB MOUNTAIN DAY FOOTBALL TEAMS, 1957. In the early 1950s, the first flag football contest was held between the Georgian and Syrreb literary societies. Pictured above is the Syrreb team, and the Georgian team is pictured below.

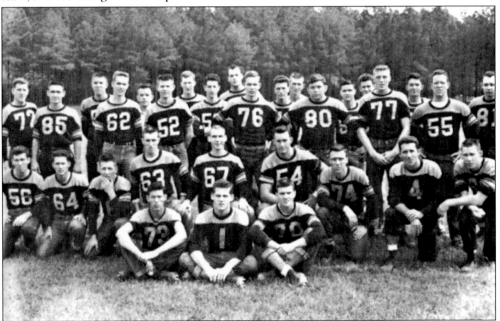

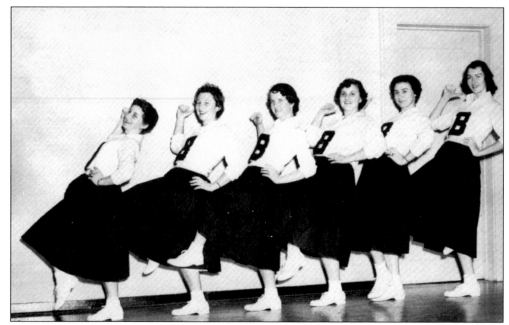

FIRST CHEERLEADERS ARE CHOSEN FOR THE COLLEGE. In 1955, the first cheerleading squad was chosen. Members of the first squad, pictured from left to right, are Joan Stokes, Jo Ann Sharpe, Shirley Philyaw, Dolly Matthews, Bettie Gene Allen, and Jerry Scott.

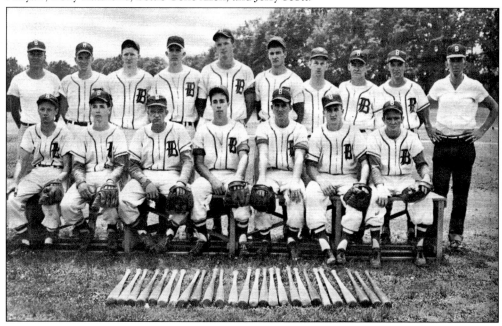

THE 1956 BERRY COLLEGE BASEBALL TEAM. Boasting a team of ten veterans and six newcomers, the Blue Jackets fielded the best college baseball team in many years, ending the season with twelve victories and one defeat. Pictured above, from left to right, are (front row) Fred DeVane, Dale Pass, Wallace Hall, Larry Hunter, Jack Allen, Harley Thomason, and Maurice Webb; (back row) Coach Charles Seeger, Carl Duncan, Mac Kilgore, Ronald Nativi, Gene Black, Billy Bentley, Leon Greeson, William Preister, Bobby Johnson, and Manager Charles Cooper.

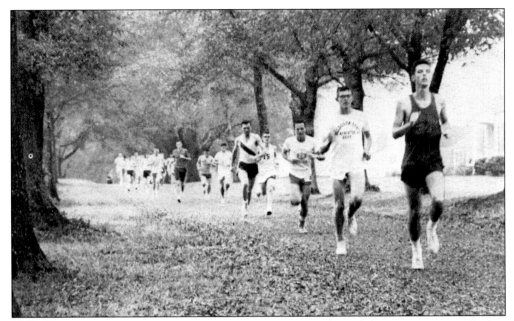

CROSS-COUNTRY MEET. In 1958, Berry became a charter member of the Georgia Intercollegiate Athletic Conference with LaGrange College, North Georgia College, Oglethrope University, Piedmont College, Shorter College, Valdosta State College, and West Georgia College. Soon thereafter, the athletic program for men expanded to include track and field, soccer, cross-country, and golf, in addition to basketball and baseball. In 1961, cross-country was held for the first time as an intercollegiate sport at the college. A race on the campus is depicted in the photograph above.

FIRST ANNUAL CROSS-COUNTRY HIGH SCHOOL RUN. In the fall of 1960, the first annual cross-country high school meet sponsored by the Rome Kiwanis Club was held at Berry. Approximately 70 boys, representing nine schools, started the event with 62 finishing the two-mile run, starting and finishing at the Berry athletic field. Pictured above is the group of runners.

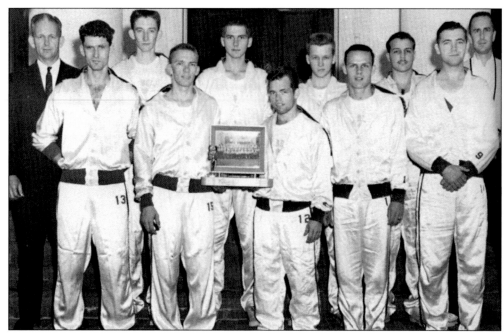

FIRST CONFERENCE CHAMPIONSHIP. The 1961 cross-country team captured the first-ever conference championship for the school, the Georgia Intercollegiate Athletic Conference (GIAC). The team is pictured above with Coaches Garland Dickey and Larry Taylor. From left to right are Dr. Garland Dickey, Jerry Cates, Roger Mull, Forrest Childre, Robert Samples, Herbert Ford, Werdna Hill, Bill McDuffie, Jack Weech, Kenneth Crabtree, and Coach Larry Taylor.

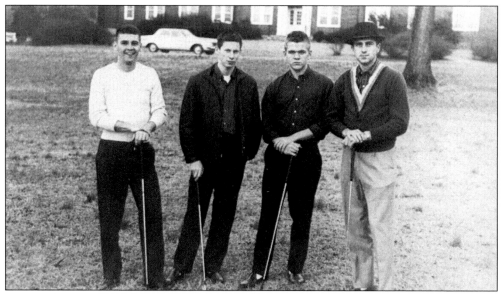

FIRST GOLF TEAM. Coach Larry Taylor is pictured above with the college's first golf team in 1962. In the late 1970s, competition in golf was cancelled and would return as a competitive sport in 1989. Pictured from left to right are Charles McDaniel, Robert Page, Stanley Aldridge, and Coach Larry Taylor.

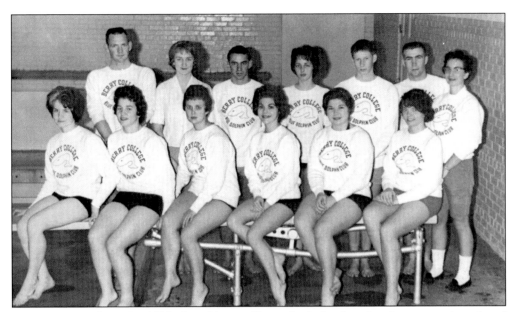

BLUE DOLPHINS CLUB. In 1958, Ann Massengill, a physical education instructor, introduced synchronized swimming as a new activity. In November of 1960, Jane B. Doss and Jeanette Crew organized the Blue Dolphins, a synchronized swim club. The 1963 club is pictured with Miss Rowe, an instructor in physical education. From left to right, they are (front row) Nancy Sims, Marilyn Waller, Ella Mae Head, Becky Miller, Jean Caines, and Beverly Arnold; (back row) Don Gaddis, Elizabeth Ralston, Dennis Mixon, Pat Threlkeld, Sam Page, Jerry McHan, and Miss Rowe.

MODERN DANCE. In 1968, Jane Doss joined the teaching staff in the Physical Education Department, where she taught until 1985. With expertise in dance and swimming, she introduced new activities into the curriculum. She is shown above giving instruction in modern dance to three students on the Ford campus.

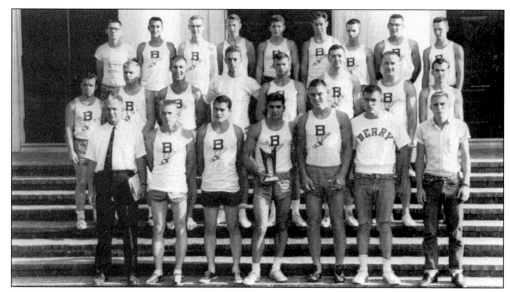

1962 GIAC TRACK CHAMPIONS. After joining the GIAC in 1958, Berry was immediately successful in track and cross-country. In 1962, the team captured the conference title for the second consecutive year by defeating West Georgia and Valdosta State. The final score was Berry College 86, West Georgia College 64, and Valdosta State University 22 1/2. From left to right are (front row) Garland Dickey (coach), Forest Childre, Eldridge Eady, Spiros Pallas, Johnny Junkins, Eugene Mobley, and Ronnie Sikes; (middle row) John Cook, Steve Garrison, Jerry McHan, Linton Dangar, Renny Bryner, Ray Maxwell, Kenneth Crabtree, and David Peaster; (back row) Jimmy Ray, Herbie Ford, Larry Sculley, Harrell McDowell, Dorsey Hightower, Gene McNeese, Thomas Abney, Terry Smith, and Ray Cox.

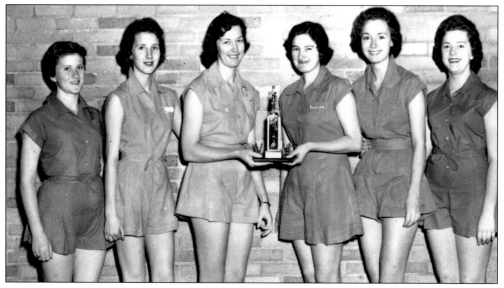

KILOWATTS WIN TROPHY. In 1955, the YWCA sponsored the first annual women's intramural basketball tournament, a tradition that continued for many years. Pictured above are the Kilowatts, the victorious team of 1958. From left to right are Melba Shipp, Eleanor Bailey, Betty Cauther, Mary Deen, Carolyn Radford, and Carol Carter. Manager Jerry Shelton and players Norma Calloway, Ann Musselwhite, and Nadine Souther are absent from the photo.

A Chronology of Selected Events in the History of Sport at Berry College from 1946 - 1981

1946
- July 10, Garland Dickey, a former student and graduate of Berry, returns from the service and becomes the first full-time athletic director and coach.
- Basketball team plays first full intercollegiate schedule.

1948
- Intercollegiate baseball is re-established after many years without competition.

1950
- First year of intercollegiate competition is held in track and field.

1955
- February 19-22, the Y.W.C.A. sponsors the first annual women's intramural basketball tournament with six teams competing in the Ford Gymnasium.
- First all-female cheerleading squad is chosen.
- Cross-country becomes an intercollegiate sport for men.

1958
- January 8, Berry becomes a charter member of the Georgia Intercollegiate Athletic Conference with seven other colleges who do not offer athletic scholarships and are concerned principally with basketball and baseball.

1959
- Men's tennis becomes an intercollegiate sport.

1960
- First Annual High School Cross-Country Meet is sponsored by the Rome Kiwanis Club and is held on the Berry Campus.

1961
- Women's basketball and volleyball teams enter competition with other schools in the form of organized play days, marking the first intercollegiate competitions for women at the College.
- Men's track team wins the first of its 7 G.I.A.C. championships.
- Cross-country becomes an intercollegiate sport for men.

1962
- First intercollegiate golf team for men is organized and coached by Larry Taylor.
- Coach Malcolm Thomas' men's volleyball team wins the G.I.A.C. Championship.
- Men's cross-country team wins the G.I.A.C. Championship.
- The student body and the Varsity Club select a new name, the "Vikings," The student center is named "Valhalla."
- October 22, intercollegiate soccer (for men) makes its debut at Berry with a defeat of Emory-at-Oxford by a score of 4-3.
- Boxers from Berry, who entered the state finals under the banner of the Rome Boy's Club, win 5 of 6 Georgia titles.

1965
- Men's basketball team defeats Mars Hill College and West Georgia College to win West Georgia Championship Tournament, the first tournament championship in ten years, ending the season with 14 victories.
- Joanne Rowe, women's basketball coach, joins representatives of Albany State College, Hiwassee College, and Georgia Baptist to organize the Southern Women's Athletic Conference (S.W.A.C.).

1966
- Baseball team wins G.I.A.C., and district championship, with a 25-10 season.

1967
- February 24, the women's basketball team (the Lady Vikings) defeats Georgia Baptist in Atlanta to win the S.W.A.C. tournament and become the first women's conference championship team at the College. Coach Joanne Rowe is named S.W.A.C. Coach of the Year.
- Fall, women's basketball team adopts new rules, with two roving players, in transition to the five-person game.

A Chronology of Selected Events in the History of Sport at Berry College from 1946 - 1981

continued

1968
- Lady Vikings win their second consecutive S.W.A.C. conference championship and Joanne Rowe is named S.W.A.C. coach of the year for the second consecutive year.

1969
- February 21-22, Women's basketball team wins Southern Women's Athletic Conference tournament at Berry, the second consecutive year and finishes second in conference play.
- Men's basketball has best record in history, 23-7 in regular season play, 2nd place in the G.I.A.C., 4th place in the Carr ratings, and a bid to the District 25 NAIA.

1972
- An equestrian course is offered for the first time at the College as a part of the physical education curriculum.
- June, four men representing Berry's track team compete in a national meet – N.A.I.A. championships – in Billings, Montana, and become the first Berry athletes to compete at a national level.

1973
- As a result of an accident involving the women's basketball team, the season was cancelled.

1974
- First annual Berry Invitational Cross-Country Race is held.
- The Eugene Gunby Equestrian Center is opened.

1976
- Women's basketball team wins Berry's first national championship–the N.A.I.A., in Ashland, Oregon–and also wins the GAIAW, Region III of A.I.A.W., averaging 83 points a game. Nancy Paris and Sharon Adamson are the first female All-Americans at the college, and Paris is chosen as MVP of tournament.

1977
- Baseball is discontinued as an intercollegiate sport.
- Women's volleyball team competes in the national championship and is ranked 10th in the nation.

1978
- Men's cross-country team wins District 25 title for the seventh consecutive time and the G.I.A.C. crown for the sixth time in the last seven years. Coach Don Jones is named Coach of the Year in District 25 and the G.I.A.C.
- May 6, the women's tennis team, with an undefeated season (12-0), becomes the Georgia State champions.
- Lady Vikings win their third consecutive GACAW small college basketball title, extend their home winning streak to 3-1/2 years, record a 17-1 season, and place 3rd in nation–the only school in history to be among the top three for three years in a row.
- Women's intercollegiate volleyball is discontinued.
- Women's track team defeats the U. of Ga. and Ga. State U. to become Georgia State College Champions, while setting 4 new college records.

1979
- October 20, the first annual men's soccer homecoming is held.
- College teams win 8 of 10 conference championships.
- Lady Vikings win state and area titles in basketball and are third in the nation.

1980
- October 30, the men's cross-country team wins its 9th G.I.A.C. cross-country championship and its 8th N.A.I.A. District 25 title.

1981
- Women's Cross-country team places second in nation.
- Coach Bob Warming's soccer team qualifies for N.A.I.A. national championship tournament for the first time in the history of the school.

WOMEN'S ANNUAL THANKSGIVING DAY BASKETBALL GAME, 1960. The annual Thanksgiving Day basketball game for women became one of the early traditions of the school. After the Syrreb and Georgia literary societies were formed, they sponsored the teams for the annual contest. In the photo to the right is Linda Dixon, leading scorer for the Syrrebs who defeated the Georgians 67-26 in the annual game.

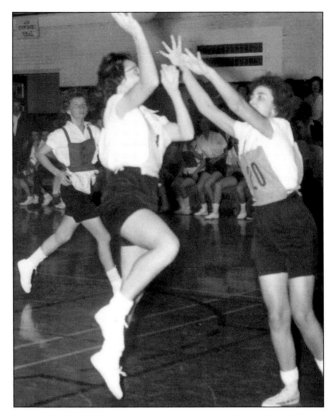

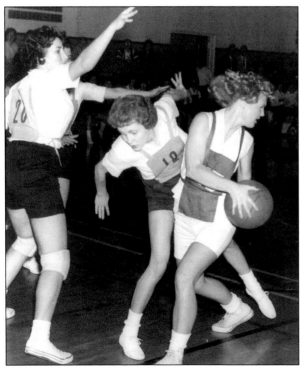

BERRY WOMEN DEFEAT WEST GEORGIA IN BASKETBALL. In the 1940s and 1950s, Play Days allowed women to enter competition with other schools when intercollegiate competition was not acceptable for women in most educational institutions. In the late 1950s, Berry entered such competitions in volleyball and basketball with West Georgia and at competitions held at the University of Georgia. On January 7, 1961, the Berry team defeated West Georgia in basketball, which may have been the first intercollegiate competition for women at the school. Pictured from left to right are Gail Knight, Jean Cox in the background, Clarie Owens, and an unidentified West Georgia player with the ball.

69

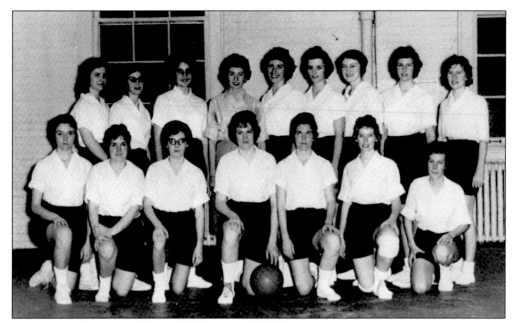

WOMEN'S BASKETBALL AND VOLLEYBALL TEAMS. Berry formed its first women's intercollegiate basketball and volleyball teams in 1961 under the leadership of Jeanette Crew, an instructor in physical education, who became the first coach. Pictured above is the basketball team. From left to right are (standing) Shirley Burke, Martha Jean Lord, Marian Loadholtz, Coach Jeanette Crew, Gail Knight, Jean Cox, Elizabeth Ralston, Mary Ann Strickland, and Mary Lucy Wimberly; (kneeling) Selma Slappy, Florence Hart, Linda Dixon, Carolyn Williams, Elizabeth Cato, Jacqueline Terrell, and Mickey Latrelle Tipton. Pictured below is the volleyball team. From left to right are Velma Ayres, Mickey Latrelle Tipton, Doris Smith, Jean Westmoreland, Martha Jean Lord, Jean Cox, and Elizabeth Cato.

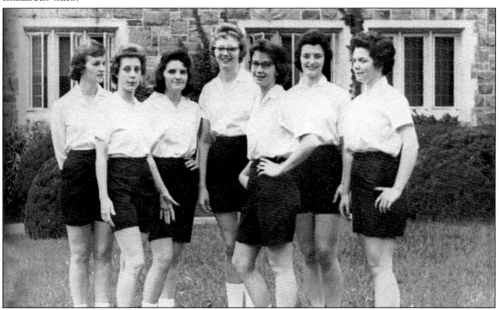

THE BERRY COLLEGE ALMA MATER.
To the left is the Berry College
Alma Mater, which was written by
Professor M.C. Ewing, professor of
music at the college from 1931 to
1938 and from 1951 to 1955.

Berry College
Alma Mater

*Far up in the hills of Georgia stands
Old Berry, tried and true,*

*The Shrine of many a memory of
The Silver and the Blue.*

*Our loyalty and love we pledge,
God keep thee without fail.*

*Be thou the light that shines for right,
Alma Mater, Hail, All Hail!*

**RICHARD "RED" CRAWFORD, THE FIRST
VIKING.** In 1962, Garland Dickey held
a contest to find a new name to
replace the "Blue Jackets," which
had replaced the "Silver and the
Blue," in the early post–World War II
years. After the name was changed
to the "Vikings," Richard "Red"
Crawford, of Rocky Face, Georgia,
became the first mascot.

71

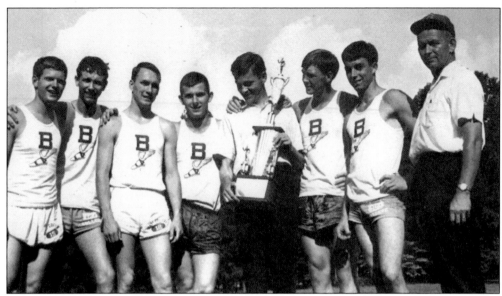

CONFERENCE CHAMPIONS IN TRACK, 1966. Pictured above are Coach Bill McAdams (holding trophy) and Athletic Director Garland Dickey, with several members of the GIAC champions of 1966. From left to right are unidentified, Roger Jones, Doyle Thomas, Bradley James, Bill McAdams, Johnny Wilson, unidentified, and Garland Dickey.

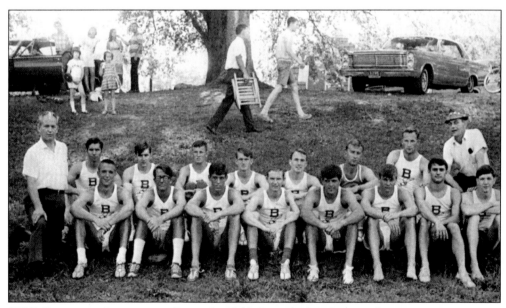

GIAC CONFERENCE CHAMPIONS IN TRACK. In 1966, Berry had its best track season since entering the GIAC in 1958. The Berry Thinclads, as the track team was known, broke six school records during the season. Pictured above with the team are Garland Dickey, athletic director, and Bill McAdams, the coach. From left to right are (front row) Dr. Dickey, Doug Price, Jim Vroom, Bill Abernathy, Roger Jones, Walter Sherman, Bobby Wilcher, Bruce Treadway, and Johnny Wilson; (back row) Harry Pugliese, Ben Cason, J.W. Bridges, Sid Stephens, Doyle Thomas, Bob Hayes, Larry Stephens, and Coach Bill McAdams.

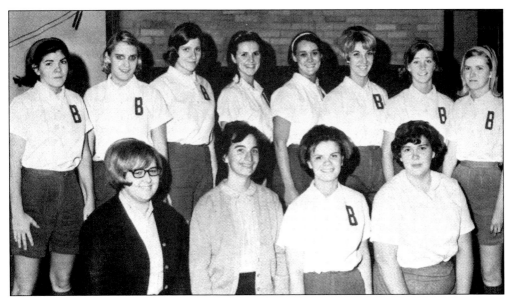

FIRST WOMEN'S CONFERENCE CHAMPIONS. In 1965, Joanne Rowe, the women's basketball coach, joined representatives from Albany State College, Hiwassee College, and Georgia Baptist College to form the Southern Women's Athletic Conference (SWAC). In February 1967, the Lady Vikings defeated Georgia Baptist to claim both the SWAC and tournament title and became the first women's conference champions at the college, ending the season with a 15-1 record. From left to right are (front row) Iris Barnes (manager) Coach Joanne Rowe, Jane Smallwood, and Doris Muse (manager); (back row) Peggy Collins, Anne Peery, Joy Baker, Frances Thurmond, Susan Bandy, Judy Haggard, Patsy Eidson, and Sharon Ingle.

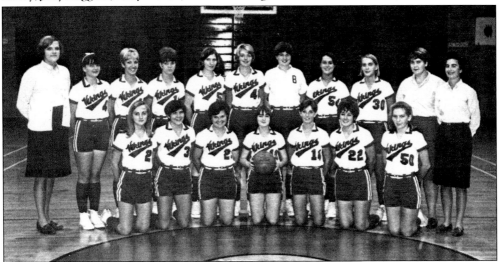

LADY VIKINGS TAKE SWAC TITLE FOR SECOND TIME. The team pictured above won the SWAC title for the second year in a row. A winning tradition in women's basketball began and continued into the 1990s at Berry. During the late 1960s and early 1970s, the women's sports program began to expand. Pictured, from left to right, are (front row) Jan Bailey, Peggy Collins, Barbara Woodruff, Linda Kinman, Patsy Eidson, Nancy Drew, and June Scoggins; (back row) Janice Spruill (manager), Sandra Lowery, Judy Haggard, Sara Bragg, Joy Baker, Janice Helmreich, Jane Rogers, Susan Bandy, Ann Peery, Doris Muse (manager), and Coach Joanne Rowe.

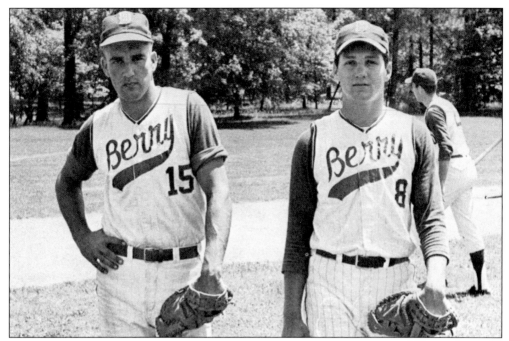

BASKETBALL CHAMPIONS, 1966. It was a championship season for the Viking baseball squad who won the GIAC, the NAIA District Championship, and was runner-up in the NAIA Area 7 tournament, winning 29 games in a single season. Pictured above, from left to right, are catchers Terry Jones and Johnny Campbell. Pictured below, from left to right, are pitchers Renny Bryner, Kenney Davis, Travis Ragsdale, and Gary Hall.

GIAC Champions in Baseball, 1966. Pictured above is the infield for the record-breaking baseball team of 1966. From left to right are Jerome (Yogi) Ayer, Don Law, David Frost, Gerry Law, Wesley Jenkins, and Charles Blalock. Pictured to the right is the outfield. From left to right are (front row) Jim Maynor and John Dixon; (back row) Pete Dees and Markinson Lawson.

BERRY WOMEN ENTER INTERCOLLEGIATE TENNIS COMPETITION. In the late 1950s, women from Berry played practice matches against Shorter, but it was 1968 before the college women entered intercollegiate competition. Pictured above from left to right are members of the 1968 team—Doris Muse, Carol Wilson, Linda Bankston, June Scoggins, and Pat Gaston.

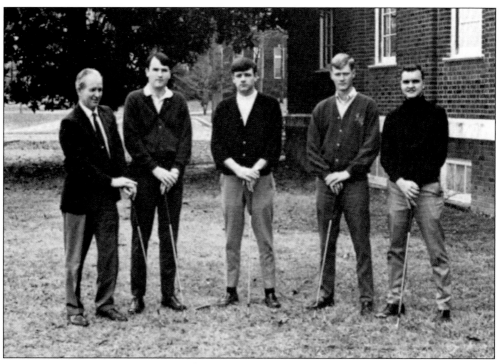

GOLFERS WIN SECOND PLACE IN GIAC. After Berry joined the GIAC, it gradually added sports to the program, which had included only basketball and baseball. In addition to track and field, cross-country, tennis, and soccer, golf became an intercollegiate sport in 1962. The golfers pictured above took second place in the GIAC in 1968 with a 7-1 record in the conference and a 12-1-1 record for the season. They are pictured with Dr. Dickey, their coach. From left to right are Ray Tucker, Doug Garwood, David Cox, and Martin Ball.

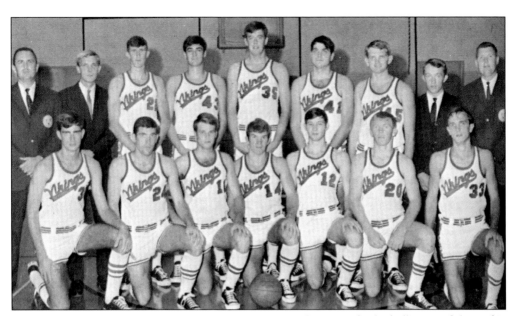

VIKINGS BASKETBALL TEAM SETS RECORD WITH 23-7 SEASON. The men's basketball team of the 1968–1969 season had the best year in the history of Viking basketball, winning 23 of 30 games in regular season play, a second place in the GIAC, a fourth place in the Carr ratings, and a bid to District 25 NAIA. Pictured from left to right are (front row) Eddie Hatcher, Charlie Hood, Don Gardner, George Johnson, Seth Bowen, Whitey Tucker, and Doug Price; (back row) Coach Larry Taylor, Fred Andrews, Mack Godfrey, Dave Faulk, Barry Griswell, Stan Worley, Terry Powell, Buster Davidson, and Coach Don Jones.

DOUG PRICE—ALL-AMERICAN. Pictured to the right is Doug Price of Indiana, who, with Renny Bryner, was the first of Berry's All-Americans, in a game against Shorter College, Berry's rival. In addition to being chosen as an all-conference track athlete, Price was chosen to the all-conference basketball team of the GIAC all four years, Most Valuable Player in the conference two years in a row, and led the conference in scoring in the 1967–1968 season with an average of 21.6 points a game. In his last season, he tied for Most Valuable Player of the Year in the NAIA.

BERRY'S SOCCER TEAM RECORDS BEST SEASON. In 1966, the Viking Fury, as the soccer team came to be known, recorded its best season in its fifth season as an intercollegiate sport—an 8-1-2 record. Pictured from left to right are (front row) Joe Haluski, Charles Burdett, Bill Apostolou, Wayne Stepowany, Ronnie Futch, Thomas Shim, Mike Toney, and James Siemon; (middle row) Dee Miller, Denny Hyde, Bruce Treadway, Johnny Wilson, Bobby Wilcher, Pete Hellstrom, Peter Sellier, Ron Allen, Don Presley, and Richard Thomas; (back row) Oktay Akbay (student coach), Roger Jones (manager), Eishin Machida, Howard Bartlett, Bill Abernathy, and Coach Bill McAdams.

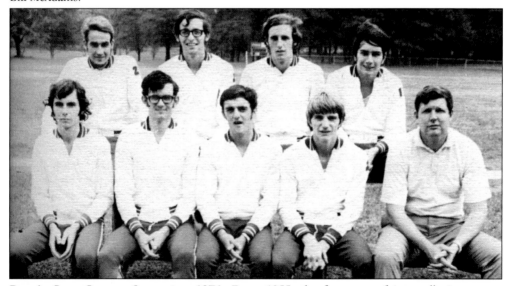

BERRY'S CROSS-COUNTRY SPEEDSTERS, 1971. From 1955, the first year of intercollegiate cross-country competition, the cross-country program was very successful. This team won the District 25 Championships, a second place—one point behind West Georgia—in the GIAC, and had a season record of 13-4-1 and a 53-19-1 record for the five years of competition. Pictured above is the team that includes outstanding runner David Bishop, who took first place in both the District 25 NAIA meet and the GIAC Conference Championship. He was also named all-GIAC for three years in a row. From left to right are (front row) Alan Armstrong, Larry Prescott, David Bishop, Moncrief Dobson, and Coach Don Jones; (back row) Richard Kauffman, Jerry Blanchard, Mickey Mahaffey, and Gerald Wagstaff.

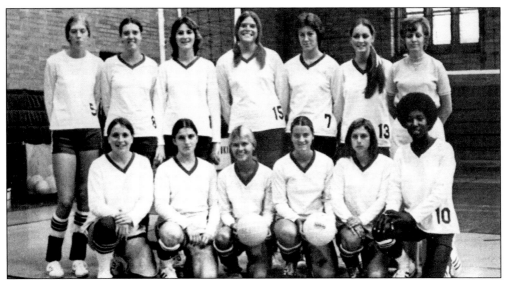

WOMEN'S VOLLEYBALL TEAM COMPETES IN NATIONAL TOURNAMENT. Formed in 1961, the women's volleyball program became quite successful under Coach Kay James. Pictured here is the 1976 volleyball team, the Viking Power, that took first-place honors in Georgia, captured second in region III, and played in the AIAW National Volleyball Championships to rank in the top 10 in the nation. From left to right are (front row) Cheryl Parker, Helen Grant, Barbara Struckoff, Leslie Elliott, Janet Finello, and Angela Garrett; (back row) Anita Middleton, Margaret Downing, Nancy Clark, Nancy Paris, Paula Dean, Kathy Hood, and Coach Kay James.

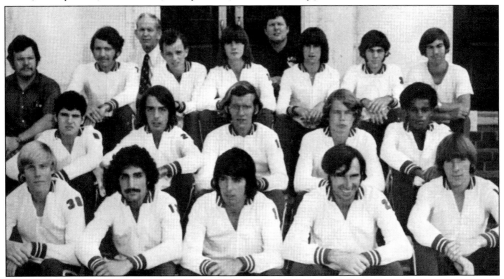

CROSS-COUNTRY TEAM HAS AN UNDEFEATED SEASON AND FIVE CHAMPIONSHIPS. The 1973 cross-country team, the Harriers, had its first undefeated season with 25 victories including a first-time win over the University of Florida and two victories over Georgia Tech. Members of the team, from left to right, are (first row) Tim Gunn, Jim Intorcia, Chris Devlin, Alan Jarmon, and John Smith; (second row) Troy White, Gary Souza, Charles Wilkie, Mike Conway, and Robert McDuffie; (third row) Manager Mark Sessions, Mike Blanchard, David White, Jerry Courtney, Dale Payne, Jerry Brawner, and Manager Jere DeFoor; (fourth row) Dr. Garland Dickey (athletic director) and Coach Don Jones.

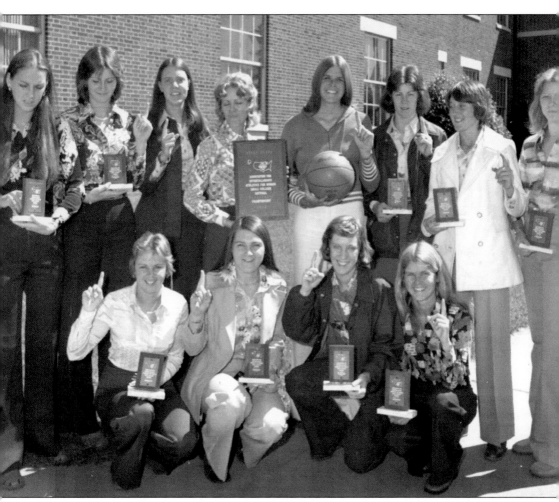

BERRY WOMEN'S BASKETBALL TEAM WINS FIRST NATIONAL CHAMPIONSHIP. In 1976, a Berry team won a national championship for the first time in the school's history, and a women's team did it. Averaging 83 points a game, the women's basketball team won the GAIAW, Region III of the AIAW, and the NAIA small college basketball championship at Ashland, Ohio, in 1976. The Lady Vikings defeated George William College 88-54, Union College 84-83, Ashland College 84-83, and West Georgia College 68-62. From left to right are (front row) Celeste Powell, Pam Pinyan, Lisa Lynn, and Barbara Struckhoff; (back row) Kathy Hood, Lynn Clark, Margaret Downing, Coach Kay James, Nancy Paris, Paula Dean, Sharon Adamson, and Deborah Rice.

NANCY PARIS AND SHARON ADAMSON, BERRY'S FIRST FEMALE ALL-AMERICANS. Pictured are Nancy Paris, number 25, and Sharon Adamson, number 14, both of whom were named All-Americans in 1976 when their team won the national women's basketball championship. Paris was also named Most Valuable Player of the tournament.

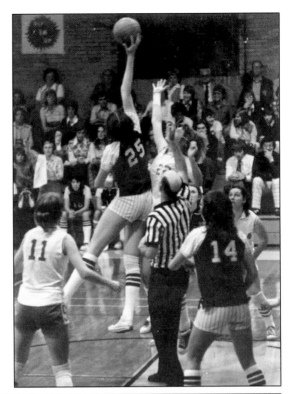

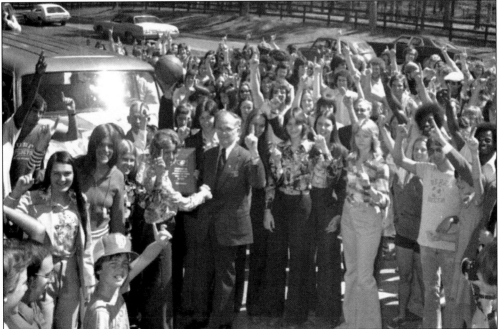

BERRY COMES BACK AS CHAMPIONS. After their victory at the National Championship in Ashland, Ohio, in 1976 the triumphant team was greeted with a parade and reception at the college. In the picture above, Coach Kay James and the team are congratulated by President John R. Bertrand and students when they returned to the college.

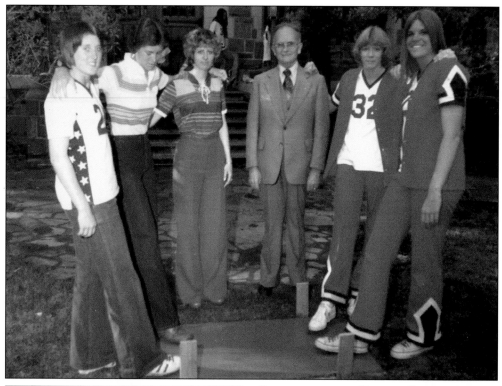

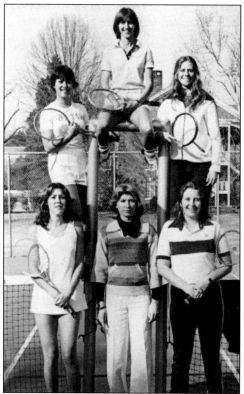

COMMEMORATING THE NATIONAL CHAMPIONSHIP. Members of the 1976 Championship women's basketball team are shown placing their feet in concrete in front of Ford Gym to commemorate their championship. From left to right are Sharon Adamson, Paula Dean, Coach Kay James, President John R. Bertrand, Debra Rice, and Nancy Paris.

WOMEN TENNIS PLAYERS ARE STATE CHAMPIONS. In the spring of 1978, the women's tennis team recorded an undefeated 12-0 season and captured the Georgia State Championship Title. The team is pictured in the photograph to the left with Coach Ann Cronic, who was also the women's basketball coach. From left to right are (first row) Kathy Brown, Coach Ann Cronic, and Jill Richards; (second row) Beth Townsend, Carol Rawlins, and Lane Reid.

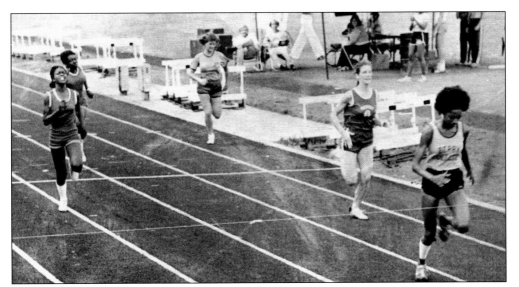

TRACK STAR VAL PETTIFORD. Pictured above in the 100-yard dash is Val Pettiford, who set a college record of 11.2 in 1979. In the same year she set a new state long jump record of 18.234 in the long jump. The 1979 team won the GAIAW state meet, breaking six state records in one meet.

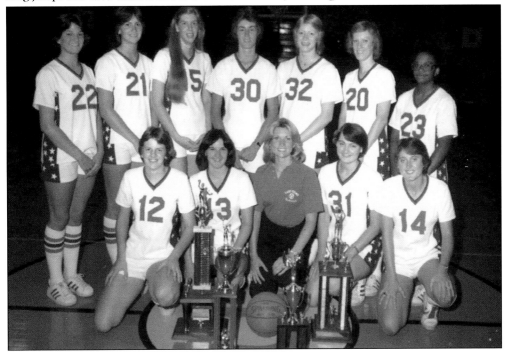

LADY VIKINGS WIN THIRD CONSECUTIVE GAIAW SMALL COLLEGE TITLE. In 1978, the Lady Vikings won their third consecutive GAIAW small college title and finished with an 18-5 season. In addition, they extended their home court winning streak to three-and-a-half years. One highlight of the season was a defeat of Shorter, which had a perfect 23-0 season, on Homecoming night. Team members, from left to right, are (front row) Clarissa Bagwell, Joanne Zebeau, Head Coach Ann Cronic, Pam Pinyan, and Sharon Adamson; (back row) Emily Broome, Lynn Clark, Anita Middleton, Paula Dean, Deborah Rice, Lisa Lynn, and Marilyn Gainor.

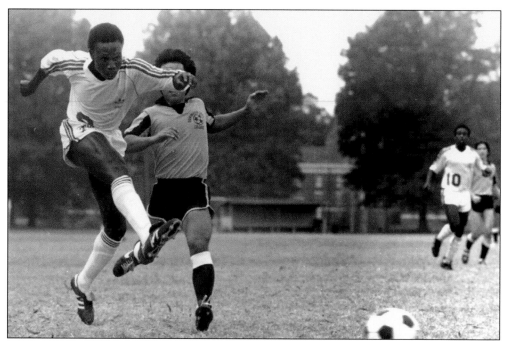

MOMODOU CONTEH, ALL-AMERICAN. Momodou Conteh of Gambia was a national leader in soccer and became the first male soccer player to be named an All-American. In the 1981 season, Conteh led his team to a 15-3 season, averaging 4.26 points per game.

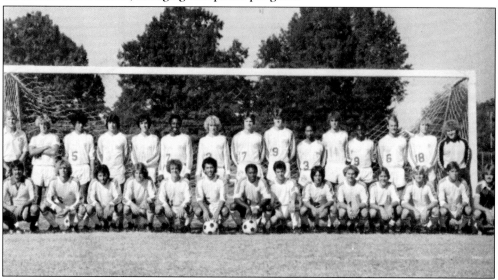

VIKING FURY VICTORIOUS. Under the direction of Coach Bob Warming, the men's 1981 soccer team ended with 15 victories and 3 losses, defeating such schools as Georgia College, the University of Tennessee, and Birmingham Southern. Pictured above, from left to right, are (first row) Duke Upchurch, Marty Apple, Chris Renner, Jimmy Jewell, John Wooten, Oscar Quinines, Mitch Dudley, Chris Triplett, Jeff Purcell, Kirk Oldham, Sac Renner, Chris Geek, Mike Telescope, and Mark Hoggat (manager); (back row) Coach Warming, Bruce Federspiel, Yohannes Worede, Greg Bennett, Jorge Mesquita, Scott Mitchell (captain), Chris Madden, Bill Sewell, Ralph Pickett, Jerry Puckerin, Jeff Smith, Momodou Conteh, Jim Lane (captain), David Morgan, and Mike Hankie.

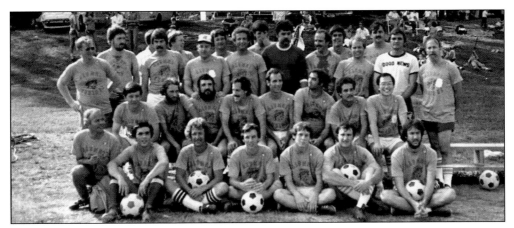

FIRST ANNUAL MEN'S SOCCER HOMECOMING. On October 20, 1979, men who played on the college's soccer team returned to the campus to inaugurate a tradition—the annual soccer homecoming. Pictured are men representing teams for several years extending into the late 1960s. From left to right are (first row) Edmund Vargas, Fernando Molina, Tommy Bright, Casey Campbell, Dennis Latimer, John Frazier, and Ken Evans; (second row) Dennis Hyde, Don Taylor, Jay Srymanski, Russell Bradley, Karl Bostick, Bruce Treadaway, Guillermo Valiente, and Koji Yoda; (third row) Lonnie Gibson, Alan Henderson, Bob Wilcher, Wayne Stepowany, Henning Bengston, Rick Walker, Wayne Rich, John Rymer, Chuck Bernreuter, and Hal Betz; (fourth row) Oktay Akbay, James Nierodzik, Howard Bartlett, David McAlpin, Keith Boylan, and Ed Palmer.

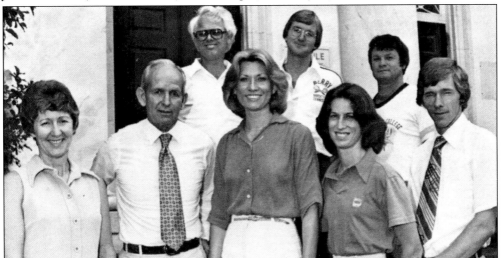

COACHES AND FACULTY OF CONFERENCE CHAMPIONS. In 1978–1979, eight of ten teams were conference champions and ended one of the most successful seasons in Berry history. Pictured above are the coaches and members of the physical education program who taught and coached many of the season's athletes. From left to right, they are (first row) Jane Doss (instructor of physical education, the drill team, the majorettes, and the cheerleaders), Garland Dickey (professor and head of the Physical Education Department and the athletic director), Ann Cronic (coach of women's basketball and women's tennis), Fran Allen (volleyball coach and head of intramurals), and John Smith (cross-country coach); (back row) Gary McKnight (women's cross- country and track coach) Bob Warming (administrative coordinator, GIAC "Coach of the Year," assistant athletic director, and coach of soccer and men's tennis), and Renny Bryner (men's basketball and track coach).

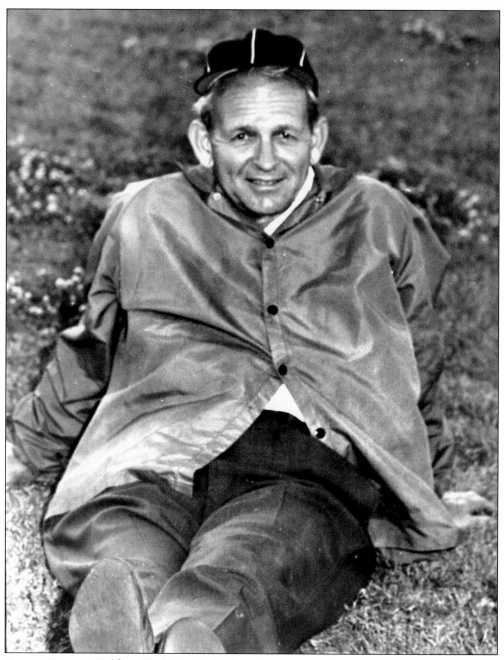

GARLAND DICKEY—1946 TO 1981. Dr. Garland Dickey is pictured watching a soccer game on the campus in 1980. In 1981, Dickey passed away after serving Berry for 35 years as teacher, coach, and athletic director.

Three

BOB PEARSON AND THE YEARS OF EXPANSION 1982–2001

—for them, defeat lies
in the open scream of a goal-mouth,
and cheers rush like surf breaking
on the bony shoulders of their private sea

"Golden Section, Giants Stadium"
—Diane Ackerman, 1991

Once again, the Berry College women's soccer team has put Rome, Ga. on the map. The Lady Fury . . . captured the N.A.I.A. national soccer championship—and some revenge—Friday afternoon in Due West, South Carolina, by downing Pacific Lutheran University 3-1 in overtime. The 1990 National Title is the Lady Fury's second championship in just five years Berry has fielded a women's soccer program.

In 1982, Bob Pearson came from Berea College to Berry to become the athletic director, head of the Physical Education Department, and soccer coach. Like his predecessors, Cook and Dickey, he continued the sporting traditions of the college. He would, also like Cook and Dickey, fashion a program that reflected his own views of sport and physical education and one that had its own distinctive character. In the early years of the program, Pearson coached many of the college's teams, as both Cook and Dickey had done. With the growth of the program and the increasing specialization in sport, however, Pearson hired individual coaches for each of the sports.

The second national title of the women's soccer team described above in the *Rome News-Tribune* was due, in large measure, to the efforts of Pearson whose imprint upon the program was one of expansion and equality—equality among sports and a movement toward equality between female and male athletes. In the closing years of the Dickey era, the college discontinued intercollegiate competition in baseball, men's golf, and track and field for both women and men, and volleyball for women and men. Soon after Pearson arrived, he began to restore a more balanced program in both the intercollegiate and intramural athletic programs. He brought back men's baseball and golf. With a declining enrollment of male students, he established three soccer teams comprised of over 70 athletes, and he supported the creation of a women's soccer team, which began as a club sport in 1982. When it became an intercollegiate sport in 1986, the program enjoyed the most immediate success of any program in the history of the school, taking second place in the NAIA in its opening season and winning three national championships in 1987, 1990, and 1993.

During this era, Berry also continued the tradition of intramural sports that began in the earliest years of the school.Through the efforts of George Bedwell, who came to Berry in the early 1980s as director of intramurals, the college developed a program that reflected the interests of the students. Less traditional activities such as water basketball, triathlon, Frisbee, and Frisbee-golf were played along with the more traditional activities of the previous era. The college added several club sports in which students could compete with other schools. The equestrian team was the first of these to be developed; it was followed by the crew team, added in 1991, and a women's volleyball team in 2000.

To support the developing soccer program, Pearson fought hard to have a soccer complex that would meet the needs of both the men's and women's teams. The complex was completed in 1987. Other facilities were needed to meet the demands of an expanding and nationally recognized program, and these were also built during Pearson's tenure as athletic director. In 1988, the new baseball complex, named in honor of Trustee Emeritus William R. Bowdoin, inaugurated the re-birth of baseball at Berry. A new tennis complex, which developed over several years to meet the needs of the men's and women's teams, was completed in 1988. Both men's and women's teams earned All-American status in the NAIA in 1990. The women's team was particularly successful winning the GIAC title every year in the decade of the 1980s. In addition, outdoor volleyball courts for intramural and recreational play were built in 1991, and the men's golf team, which claimed its first national championship in 1998, gained its own course when Stonebridge Golf Course was completed in 1994.

The national reputation of Berry's intercollegiate sports program was furthered by their hosting of district and national championships for the first time in the history of the college. In 1984, Coach Brenda Paul, one of Berry's most successful coaches, hosted the District 25 play-offs in basketball. In 1994, Berry hosted its first national competition, the NAIA National Soccer Championship for Women on the Berry Campus. In 1995, it hosted the tournament again.

National recognition was also achieved in 1991 when the women's athletic program was ranked 10th in the nation by the National Association of Intercollegiate Athletic Sports Information Directory Association. The ranking, based on post-season competition, further attested to the success of women's sports, which Pearson had supported and nurtured from his first days at the college. The balanced program that Pearson sought is symbolized by another award. In 1996, the athletic program was ranked fourth in the competition for the Sears Cup, awarded for overall success in both women's and men's sports. Berry has continued to be ranked in the top 20 schools in the country for many years.

Pearson also affected the sports program by moving Berry into a new conference. In 1996, with the opinion that Berry should compete with schools of similar size that have similar philosophies and academic standards, Berry joined the TranSouth conference, which consisted of 10 other schools, most of which are in Tennessee.

In the last years before its centennial celebration, the athletic program at the college had been expanded in terms of coaches, facilities, and teams. By restoring sports that had been discontinued before he came to Berry, adding coaches and teams for women, and constructing facilities to meet that expanding program, Bob Pearson created a well-balanced, nationally recognized program of athletics that included more sports and more female athletes than ever before.

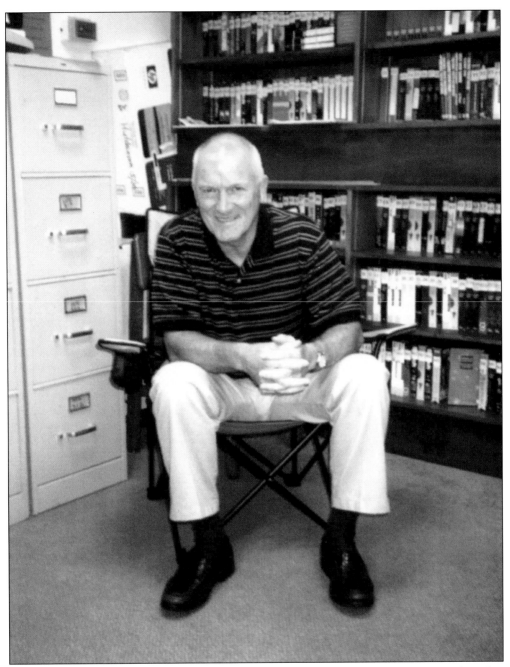

Bob Pearson. In 1982, Bob Pearson came from Berea College to replace Garland Dickey as athletic director and the head of the Physical Education Department. Like Dickey, he also assumed the role of coach in a number of sports. Pearson worked to expand the program of sports by bringing intercollegiate baseball and golf back and by expanding the men's soccer program and adding intercollegiate soccer for women. To support these programs, he added a new baseball and soccer complex and a renewed tennis complex. He is pictured in his office in Richards Memorial Gym, where he serves as head of the Health and Physical Education Department.

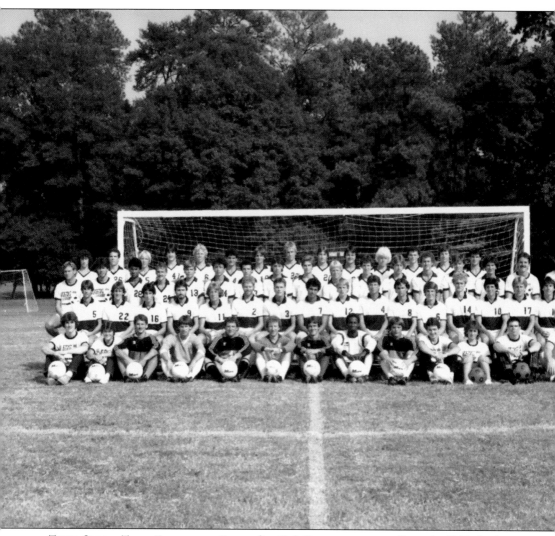

THREE SOCCER TEAMS ESTABLISHED. Soon after Bob Pearson came to Berry in 1982, he began to develop the men's soccer program. During years of declining enrollment of male students Pearson created three soccer teams—a varsity, a junior varsity, and a freshmen team. Pictured above are the three teams in 1985.

SOCCER PRACTICE AT HERMANN HALL. The expansion of the men's soccer program required additional practice fields to accommodate the three teams that Pearson developed soon after his arrival in 1982. With over 70 soccer players, there was a shortage of soccer fields. To draw the administration's attention to the need for more fields, Pearson set up soccer goals on the lawn of Hermann Hall. Pictured above is one of the teams practicing on the lawn. As a result, the soccer complex pictured below was completed in 1986.

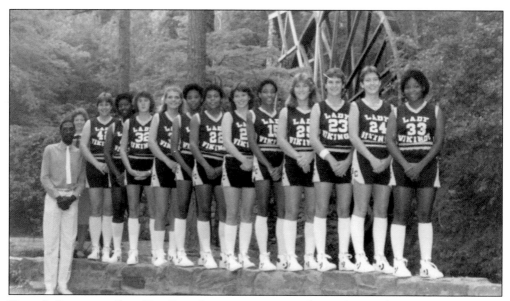

WOMEN'S BASKETBALL TEAM HAS BEST SEASON EVER. In 1984, Coach Brenda Paul's Lady Vikings completed the best season in history—a 32-5 record, a District-25 Championship, reaching the final four of the NAIA, and recorded 100 wins in three seasons. Pictured above in front of the Old Mill, from left to right, are Rufus Cotton (assistant coach), Brenda Paul (coach), Kim Scruggs, Karen Kemp, Theresa Pack, Carol Owen, Phyllis Thompson, Kitty Rucker, Beth Daves, Michele Tuggle, Paula Skinner, Connie Guinn, Robin Hoffman, and Deidra Adams.

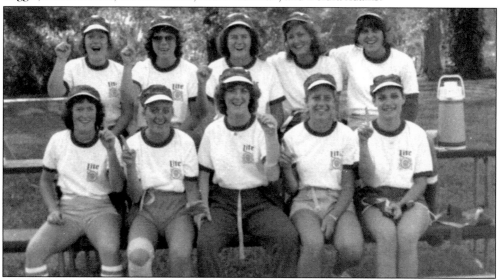

HURRICANES WIN WOMEN'S INTRAMURAL FLAG FOOTBALL COMPETITION. Under the leadership of George Bedwell, who came to Berry in the early 1980s as director of intramurals, the program of intramurals expanded to include a more varied program as well as a program that increased opportunities for female students. Pictured above are the Hurricanes, who won the women's intramural flag football competition in 1983. From right to left are (front row) Lynn Campbell, Lynn Finnegan, Sherrie Odum, Paige Moore, and Karen Robertson; (back row) Suzanne Thornton, Jill Long, Brandi Williams, Lisa Weldon, and Lisa Brasher. Not pictured are Beth Van Landingham, Lacey Guest, and Marty Allison.

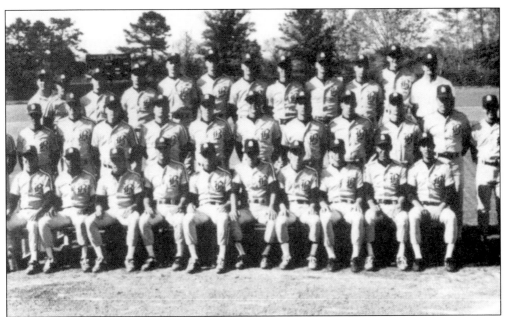

BASEBALL RETURNS TO BERRY. In 1988, a new baseball complex, named in honor of Trustee Emeritus William R. Bowdoin, was completed, and Coach John Schaly began to develop a baseball program at the college. Pictured above is his 1990 team. From left to right are (front row) Brian Hickey, Rodney Wilson, Todd Brophy, Dave Helton, Captain Scott Gilky, Mark Piecoro, Mike Klug, Ty Carter, Sam Petershime, and George Gornowicz; (middle row) Head Coach John Schaly, Assistant Coach Joey Davis, Drew Beach, Anthony Agbay, Martin Hussey, Bart Lewis, Dave Brannon, Chan Echols, Mike Sokolowsky, Britt Brumby, Student Assistant Coach Bob Koch, and Student Assistant Coach Todd Middleton; (back row) Student Manager/Statistician Pete Allen, Jason Peck, Rob Taylor, Bobby Ferebee, Chance Cane, Ed Autry, John Davis, Mike Matvey, T.J. Search, Rob Stealey, Doug Roberson, and Trainer Robin Gaines. Action on the new field is shown in the photo to the right. (Photo by Joe Benton.)

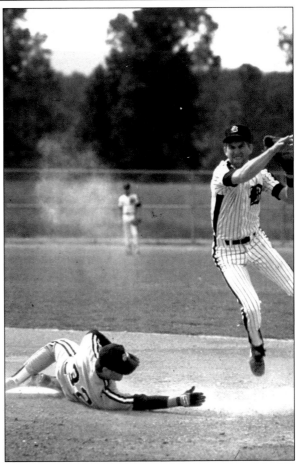

93

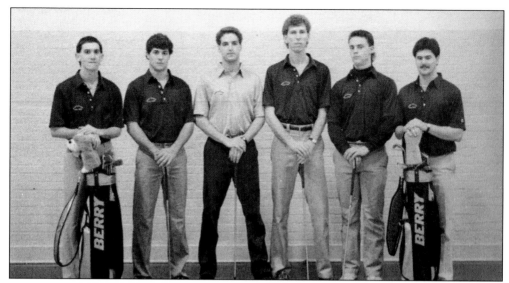

GOLF TEAM, 1988. In the late 1970s, the college discontinued intercollegiate competition in men's and women's track and field, women's volleyball, baseball, and golf. Soon after Bob Pearson became the athletic director, he brought back some of these sports and added other new sports to the athletic program. Men's golf was one of those that he brought back. Pictured above is the first team. From left to right are Josh Walton, Greg Lang, Coach Paul Clark, Bill Marvel, Michael O'Grady, and Ronnie Siniard. Not pictured is Chuck Holt.

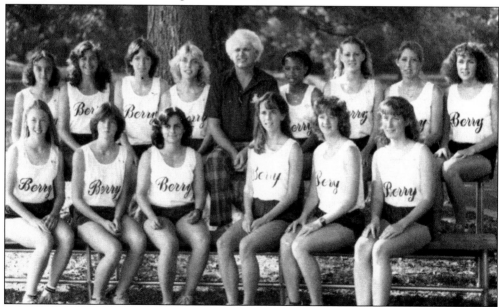

WOMEN'S CROSS-COUNTRY ESTABLISHED. Women runners continued to compete in cross-country, even after track and field was discontinued. Pictured above is Coach Gary Knight's 1982 team, which competed in the AIAW regional III meet and in the NAIA national cross-country championship. From left to right are (first row) Diana Cook, Lori Cobb, Arden Levy, Trina Buce, Tracy Steele, and Stacy Scallion; (back row) Beth Richmond, Nora Conner, Cindy Campbell, Karan White, Coach Gary McKnight, Beverly Cable, Kellie Ruse, Teresa Leinmiller, and Edie Brantley.

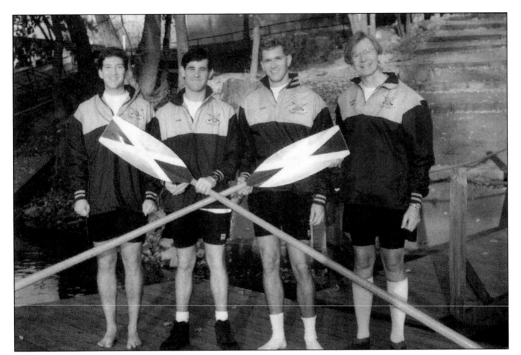

CREW TEAM ESTABLISHED AS CLUB SPORT. In the fall of 1991, Gus Stallings, inspired by his sister's rowing at the University of Tennessee in Chattanooga, contacted Dr. Hamilton Dixon, a rower in Rome, about starting a team. He also recruited Chris "Pops" D'Angelo, a student at the time, to join the team, and a Viking crew team was established. The team has continued as a club sport into the Centennial year. Pictured above in 1994 from left to right are Gus Stallings, Chris "Pops" D'Angelo, Dave Corbin, and Dr. Hamilton Dixon.

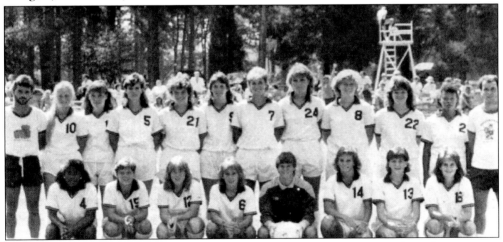

FIRST WOMEN'S SOCCER TEAM GOES TO NATIONALS. Known as the Cinderella Team, the Lady Fury soccer team competed in the NAIA national tournament in 1986, the first time that a first-year team had competed in the national tournament. Team members, from left to right, are (front row) Andrea Taylor, Anne Felts, Amanda Wilson, Amy Snyder, Kathy Drew, Jennie Taylor, Margaret Peek, and Susan Mendelson; (back row) Coach Ray Leone, Madeleine Grant, Tina Conway, Natalie Smith, Jenny Link, Carol Chilton, Anjie Hale, Julie Schulte, Laura Kolb, Jodi Reagin, Yvonne Smith, and David Baird (assistant coach).

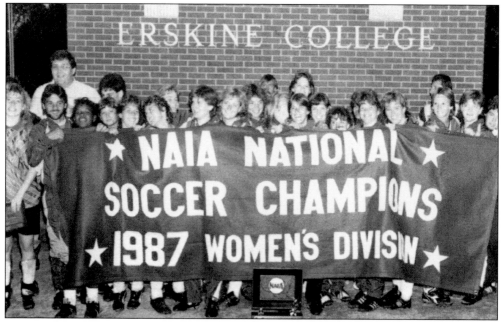

WOMEN'S SOCCER TEAM WINS FIRST NATIONAL TITLE. The Cinderella team of 1986 became national champions in the following year by defeating Erskine College 1-0 in the final game. This made them the second team from Berry to win a national championship. Following the awards ceremony at Erskine College, the Lady Fury show off their victory banner, which was later displayed in the lobby of the Krannert Center to honor the team. Coach Ray Leone was named NAIA "Coach of the Year."

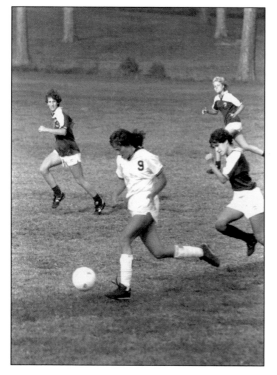

CAROL CHILTON, FIRST FEMALE SOCCER ALL-AMERICAN. Carol Chilton, member of the National Championship team, is photographed during a match. Named as Berry's first female All-American soccer player, Chilton's record 27 season goals in 1986 would remain unbroken until 1998, when Laila Modi ended her season with 33 goals. Her career goals record of 72 was broken in 1998, when Modi scored her 83rd goal.

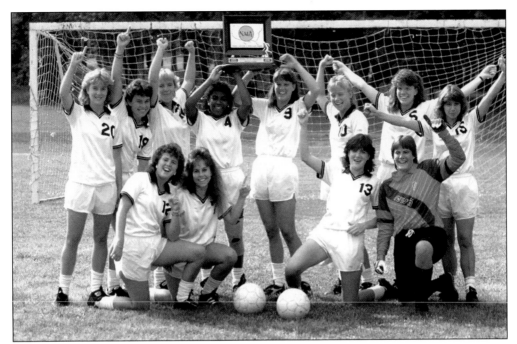

NATIONAL CHAMPS OF 1987. Pictured above is the 1987 National Championship team with the NAIA trophy hoisted in victory on the field at Erskine College in celebration of the first of three national titles that the Lady Fury would win.

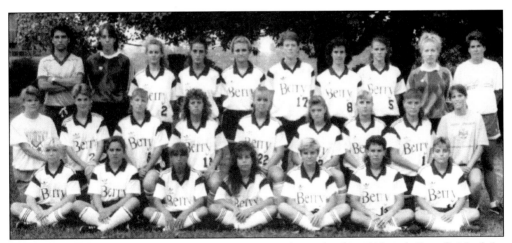

SECOND NATIONAL CHAMPIONSHIP IN WOMEN'S SOCCER. Becky Burleigh's 1990 Lady Fury finished the season with a record of 16-5-2, captured their second national championship, the District-25, and the East Regional Championship for the fifth year in a row. Burleigh was named the NAIA National Women's Soccer Coach of the Year. Pictured from left to right are (front row) Patty Bacon, Jennifer Reynolds, Nicki Courtney-Greene, Justine Franzke, Amy Hallmark, Renee Ridgeway, and Johnna Czar; (middle row) Jodi Reagin, Julie Terry, Kristen Mayo, Pam Burnett, Kelley Broen, Susan West, Ashley Rose, Tina Conway, and Carol Chilton; (back row) Alfredo Moya (assistant coach), Laura Lowrey, Emily Pritchard, Dawn Dowd, Holly Freeman, Lynn Heath, Alison Costner, Rosemary Peek, Laura Hamilton, and Becky Burleigh (head coach).

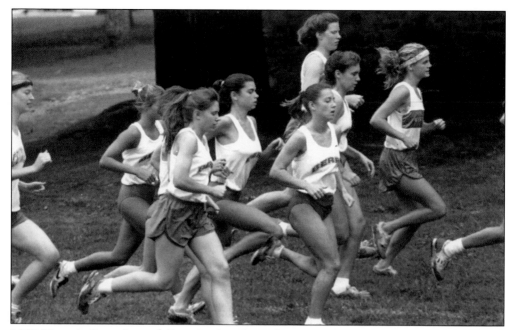

1992 WOMEN'S CROSS-COUNTRY TEAM. In the photo above, Coach Michele Penny's runners move through the pack during a race on the mountain campus. The Lady Viking team placed 18th at the national meet in Kenosha, Wisconsin. Junior Michelle Palmer placed ninth individually out of 349 runners in 1992. Berry runners pictured from left to right are Andi Porter, Sunny Deaton, Erin Muntzing, and Tammy Seblink.

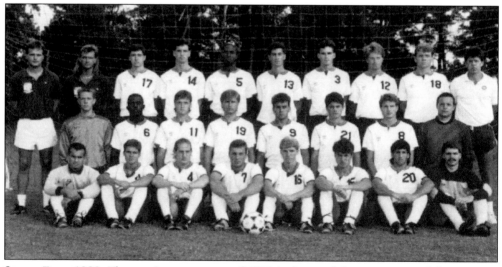

SOCCER FURY, 1990. The men's soccer team of 1990 had one of the most successful seasons in their history with a 16-4-2 record. They tied the school record for shutouts with 10 and scored the most goals in a season since 1981. Pictured from left to right are (front row) Geoff Walsh, Scott Hardester, Andy Kimball, Ernie Broennie, Jay Pruitt, Jason Page, Lindsey Inderdonati, and Sean Dresser; (middle row) Ryan McGee, Kevin Edwards, Niel Brown, Tom Rigsby, Steve Hull, Chad Thomas, Scott Clay, and Robbie Henson; (back row) Joel Couch, Mark Christianson, Chris Homer, Terry Cole, Ron Wiggins, Chris Cooley, Dwayne Crook, Rich Murlin, Drew Bell, and Coach Brett Simon.

A Chronology of Selected Events in the History of Sport at Berry College from 1982 - 2002

1982
- Dr. Bob Pearson becomes the athletic director and head of Health and Physical Education Department and serves in this capacity until 1992, and then again from 1994-1996.

1983
- Women's soccer appears in the form of a club sport.

1984
- Coach Brenda Paul's women's basketball team, the "Lady Vikings," score their 100th win in three years, and Berry hosts District 25 play-offs for women's basketball.
- Track is discontinued as an intercollegiate sport.

1986
- Women's soccer becomes an intercollegiate sport, and the team plays in the N.A.I.A. finals, marking the first time that a first-year team competes in the final tournament.
- Both women's and men's tennis team win the G.I.A.C. championships, the first in thirteen years for the men and the fifth in five years for the women.
- Ford soccer fields are completed.

1987
- November 21, the Lady Fury soccer team, in its second year of N.A.I.A. competition, captures the national championship by defeating Erskine College 1-0. Coach Ray Leone is named N.A.I.A. Coach of the Year.

1988
- Renovation of Memorial Gymnasium is completed, and the gym is renamed the Roy Richards Memorial Gymnasium.
- An impressive new baseball complex, named in honor of Trustee Emeritus William R. Bowdoin, inaugurates the rebirth of baseball.

1989
- Women's tennis team wins its 8th consecutive G.I.A.C. championship.
- Only in its second year, Berry's baseball team wins the G.I.A.C. championship.
- A men's intercollegiate golf team resumes competition on an intercollegiate level.

1990
- Women's soccer team, the Lady Fury, wins the national championship at Erskine College for second time.
- Paul Deaton is 6th in the marathon in the N.A.I.A., the first Berry student to receive All-American honors as a marathon runner.

1991
- The Sports Information Directory Association ranks Berry College Women's Athletic Program tenth in the N.A.I.A.
- Fall, Viking Crew is established as a club sport.
- Women's basketball team has a 26-7 record and goes to the national tournament, for the first time since 1984. Lee-Anda Hutchens is named Atlanta Tip-Off Club Player of the year and G.I.A.C. Player of the Year.

1992
- May 2, the women's tennis team earns its first N.A.I.A. district title, makes its third trip to the national tournament (May 18-23), and is ranked thirteenth in the nation.
- May 6 - 7, the men's golf team wins its first N.A.I.A. District 25 G Championship at the Farm in Dalton, Georgia.
- Men's basketball team compiles a 27-8 record, wins the Georgia Athletic Conference Championship, and advances to the N.A.I.A. national tournament for the first time ever. Philip Verlander is named District Player of the Year and Northwest Georgia Player of the Year.
- Women's basketball team, with a 27-8 record, wins the district title, and competes in its second, consecutive N.A.I.A. national tournament.

continued

1993
- Women's soccer team, the Lady Fury, wins its third national N.A.I.A. championship in St. Louis.
- Coach Connie Guinn, former Lady Viking, finishes her ten-year career at Berry with 209 victories to become the coach with the most victories in women's basketball.

1994
- November 21-26, Berry hosts the N.A.I.A. women's soccer national championships on the campus.
- Coaches George and Robina Gallagher's equestrian team represents the southeast region in the Intercollegiate Horse Show Association National Finals.

1995
- Berry hosts the N.A.I.A. women's soccer national championships for the second year.

1996
- Berry joins TranSouth Conference with 10 other prestigious schools from Alabama, Arkansas, Georgia, and Tennessee.
- Berry places fourth in the N.A.I.A. Division of the Sears Directors' Cup.
- Women's soccer team is third in the nation, and sets a program record for wins in a single season with a 20-3 record, a record it repeats in 1998.

1998
- Men's golf team wins 7 of 8 tournaments, the TranSouth Conference Tournament, and its first N.A.I.A. National Championship at Southern Hills Country Club in Tulsa, Oklahoma, after having been runner-up in 1994 and 1996.
- Men's baseball team wins 2nd place in the TranSouth Conference Tournament and advances to the N.A.I.A. Regional Tournament.
- Soccer player Laila Modi scores a record 28 goals for a season to break Carol Chilton's 27 goals of 1986, ending the season with a total of 33 goals. A year later, she breaks Chilton's career record of 72 goals with 83 career goals.

1999
- Berry produces its first individual national champion, Michelle Abernathy, her 12th N.A.I.A. All-American award for the marathon at the N.A.I.A. Outdoor Track and Field National Championships in Florida to become the most decorated athlete in Berry history.

2000
- Women's volleyball becomes a club sport and will become an intercollegiate sport in 2003.

2001
- Men's soccer team sets a school record with 17 wins, a 17-5 overall record, its first TranSouth title, and participation in the N.A.I.A. national tournament for the second time in the history of the School.
- Women's soccer team has a 20-4 season and qualifies for the national conference tournament after a two-year absence; Coach Lorenzo Canalis is named TranSouth Coach of the Year for the fifth time.

2002
- First year of intercollegiate competition for women's golf.
- Three Viking runners qualify for the N.A.I.A. outdoor track and field championships.
- A new hardwood floor replaces the artificial surface in Roy Richards Memorial Gym.

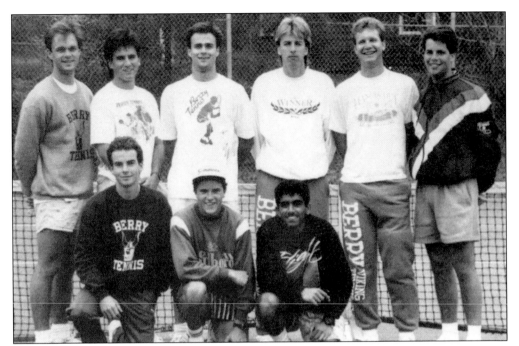

MEN'S TENNIS TEAM NATIONALLY RANKED. The 1990 men's tennis team was ranked 21st in the National Association of Intercollegiate Athletics, the first time that the men's team had been nationally ranked. The team, composed of players from Sweden, South America, Pakistan, England, and the United States represented a development in sport at the college—that of recruiting international students into the athletic program. Pictured from left to right are (front row) Richard Lunney, Paul Brown, and Kaleem Ghanci; (back row) Shane Phitides, Lewis Cochius, Ashley Schubert, Hakan Darud, Jeff Jones, and Head Coach Mike Byrne.

TENNIS COMPLEX COMPLETED. After Bob Pearson assumed the position as athletic director at the college, he began to develop the athletic facilities with the addition of a new soccer complex and baseball field. He also improved the tennis complex, which was completed in 1988 and is pictured above.

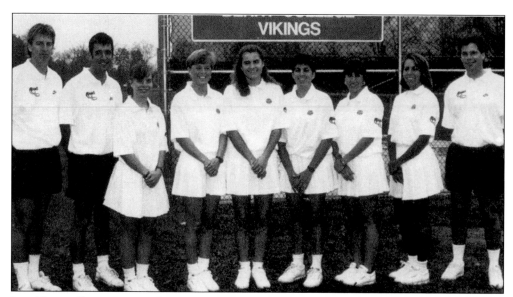

LADY VIKINGS TENNIS PLAYERS GO TO NATIONAL TOURNAMENT. In 1992, the Lady Vikings earned their first NAIA district title and their third trip to the national tournament. They completed their season ranked 13th in the nation with a record of 16-8. The team is pictured above. From left to right are Assistant Coach Hakan Darud, Assistant Coach Mark Byrne, Ginger Swann, Ann Marie Circle, Nancy Malone, Lisa Frangipane, Vicki Sica, Michaele Flynn, and Head Coach Mike Byrne.

TENNIS PLAYER AT THE FORD BUILDINGS. The lovely sculpture, depicting a female with a racket in her hand, adorns one of the buildings of the Ford Buildings, completed in the early 1930s.

COACH CONNIE GUINN CELEBRATES 20 VICTORIES IN 1990–1991 SEASON. In the photograph to the right, Coach Connie Guinn, former Lady Viking, cuts the net in Ford Gymnasium to celebrate the Lady Vikings return to a season of 20 victories. The team also advanced to the NAIA tournament with a record of 26-8.

LADY VIKINGS CELEBRATE 20 VICTORIES. In the photograph below are players on the 1990–1991 women's basketball team, which celebrated a season of 20 victories, won the District 25 championship, and competed for the national title. They are, from left to right, Lee-Anda Hutchens, Christie Herndon, Stephanie Caudell, and Denise Crowell. Hutchins is one of the most celebrated of the Lady Vikings, becoming the most prolific scorer in the history of women's basketball at Berry. Ending her career with 2,111 points and over 1,000 rebounds, the Rome native was named Atlanta Tip-Off Club's Player of the Year (1991) and the Northwest Georgia Tip-Off Club Player of the Year (1991). She was also the Georgia Intercollegiate Athletic Conference Player of the Year as a junior and received All-District honors four times. (Photo by Joe Benton.)

Men's Basketball Team Goes to Nationals for First Time. In 1992, the men's basketball team completed the most successful season in the history of the program. They had a 27-8 season, won the Georgia Athletic Championship, and advanced to the NAIA annual tournament for the first time ever. Pictured from left to right are (front row) Rob Bowen, Demetric Johnson, Lee Tiller, Coach Todd Smyly, Will Witherington, and Hillary High; (back row) Brian Cothran, Philip Verlander, and Tommy Tormohlen. (Photograph by Paul O'Mara.)

Philip Verlander takes Honors. Senior Philip Verlander, a member of the 1991–1992 basketball team, finished his four years at Berry with distinction. Scoring 44 points in one game alone, Verlander was named District Player of the Year, Northwest Georgia Player of the Year, and a member of the All-District/All-Conference Team.

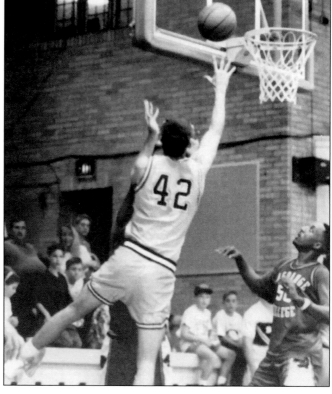

INTRAMURALS AT THE COLLEGE.
Intramural competitions formed
the foundations of sport in the early
years of the college and sustained
the Viking tradition through the
1930s when there were very few
intercollegiate competitions. The
intramural program continued to
flourish with newer sports like beach
volleyball and softball, as shown in
these photographs.

JESSICA CLEMENTS PRACTICES HUNTER-JUMPER COURSE. In 1972, the first equestrian course was offered at the college as a part of the curriculum in physical education. As interest in the sport increased, an Equestrian Club was established, the Eugene Gunby Equestrian Center opened in 1974, and later a team was formed. The team competes with schools across the South including the University of Georgia, Georgia Southern, College of Charleston, Erskine College, and West Georgia College. Pictured above is Jessica Clements (2002) practicing the Hunter-Jumper course.

BERRY EQUESTRIAN TEAM REPRESENTS THE SOUTHEAST REGION IN NATIONAL COMPETITION. In 1994, Coaches George and Robina Gallagher took their equestrian team to the Intercollegiate Horse Show Association National Finals at Texas A&M University. Pictured above are members of the team. From left to right are (first row) Tara Turner, Amy Brant, Cherie Osman, Shannon Borges, and Kristen Daniel; (second row) Ceebee Ross, Stacey Grosvenov, Jen Winnick, Persephone Chandler, Janelle Julyan, and Bonnie Kerr; (third row) Angie Kellog, Blair Waddell, Michele Gandy, Wendy Vannerson, and Meredith Evans; (fourth row) Chanda Ross, Christy Proffit, Tricia Giametta, Elizabeth Spangle, Kim Godwin, and Matt Walton.

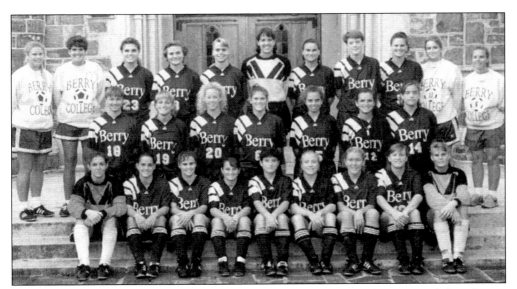

LADY FURY WINS THIRD NATIONAL TITLE. The Lady Fury, with an 18-4-1 season, defeated Lynn University to win the NAIA National Championship for the third time. From left to right are (front row) Sherry Wilson, Beth Butcher, Gina Genduso, Becky Rundberg, Lauren MacGuire, Patty Bacon, Kathy Insel, Kris Mayo, and Tammy Scott; (middle row) Jeni Hammel, Lana McHugh, Regina Peek, Alyson Simpson, Michele Kelmer, and Nancy Jones; (back row) Jennifer Lewis (assistant coach), Becky Burleigh (head coach), Jenny Miguel, Holly Freeman, Ashley Surles, Laura Lowery, Tracy Moll, Lynn Heath, Rose Peek, Ginger Swann (trainer), and Karyn Dierking.

CHAMPIONSHIP TROPHY. Pictured to the right is the Lady Fury's third National Championship Trophy. (Photo by Joe Benton.)

NEW GOLF COURSE FOR BERRY. In 1994, Stonebridge Golf Course was built north of the campus and became the home course of the Berry teams, which has included a women's intercollegiate team since 2001. Two Berry golfers are shown in the photograph above crossing the bridge to the ninth hole.

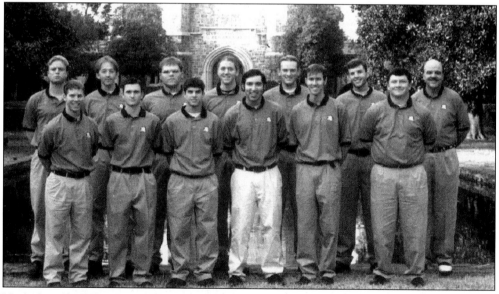

MEN'S GOLF TEAM WINS FIRST NATIONAL CHAMPIONSHIP. In May 22, 1998, the men's golf team won its first NAIA championship at Southern Hills Country Club in Tulsa, Oklahoma, after having been runner-up in 1994 and 1996. In addition, the team won seven of eight season tournaments and the TranSouth Conference Tournament. Members of the team are pictured above. From left to right are (front row) John Thomas Horton, Damon Stancil, Lance Cone, Will Pettus, Mike Howren, and Dan West; (back row) Ed Cunliffe, Matt Evans, Paul Johnson, John Cornette, Joey Hutchins, Rusty Estes, and Coach David Goddard.

WOMEN'S VOLLEYBALL TEAM SOON TO ENTER INTERCOLLEGIATE COMPETITION. In 2000, women's volleyball was re-established at the college after it was discontinued in 1978. Pictured above is the club sport team of 2001, which will enter intercollegiate competition in 2003. Members of the team, from left to right, are (front row) Heather Henderson, Nikki Worth, Dawn Ekema, Shannon Funai, and Lindsay Black; (back row) Erin Harvey, Andi McKenzie, and Jenica Smith.

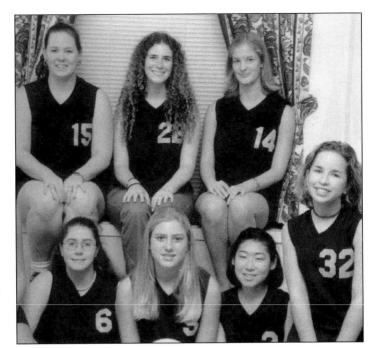

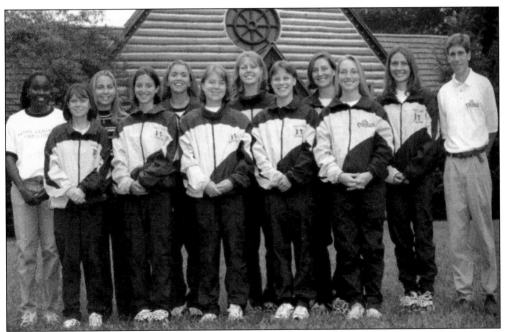

WOMEN'S CROSS-COUNTRY TEAM CARRIES WINNING TRADITION. Coach Paul Deaton's women's cross-country team of 1998–1999 continues a winning tradition that was established when Berry began an intercollegiate cross-country program for women in the early 1980s. Pictured in front of Barnwell Chapel, from left to right, are (front row) Michelle Abernathy, Katy Moore, Melinda Larson, Mary Mingledorff, and Stephanie Jacobs; (back row) Reagan Mills, Jacqueline Lance, Barbara Jane Taylor, Karmen Hennigan, Shawn Harris, Shane Harris, and Paul Deaton (coach).

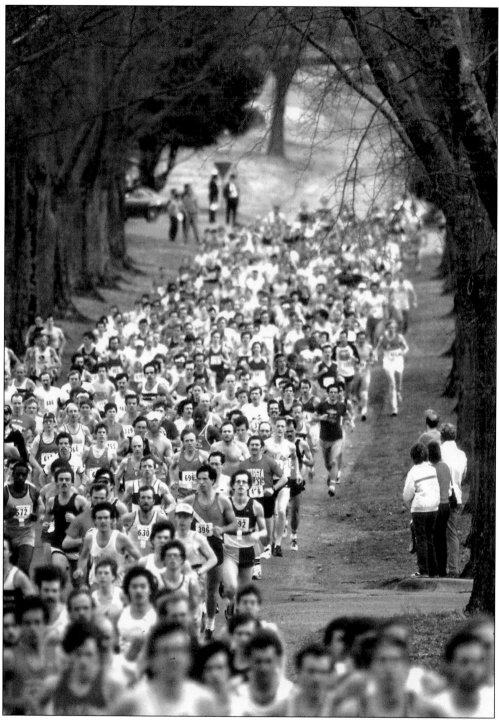

THE VIKING CLASSIC. The Viking Classic has been held at Berry in March of every year for 20 years. Throughout the years it has brought many elite and nationally known runners to the campus to join other runners in the ten-kilometer, five-kilometer, and one-mile fun run. Runners are shown above, along the tree-lined road behind Hermann Hall on the campus.

Four

CENTENNIAL YEAR
2002

. . . we have found
This place where the gods play out the game of the sky
And bandy life and death across a summer ground.

"A Game of Ball"
—Muriel Rukeyser

Trading in her soccer cleats and shin guards for a Berry College singlet and running shoes, senior Miriam Galeas became a two-sport athlete for Berry on Saturday. After completing a successful senior season for the Lady Viking soccer team in the fall, where she scored 14 goals, added nine assists, and was named an athletic and academic All-American, Galeas joined the Berry running team to compete in some indoor meets this spring. At the Smith Barney Invitational, hosted by Butler University, she participated in the 800-meter race.

In the summer before his senior year, while many Berry students were studying about Spain or Brazil in their classes, one member of the Viking soccer team is seeing these countries up close and personal this month. Eddie Loewen will be in both countries this week, representing his home country of Germany in the European Championships and the World Championships of beach soccer.

These accounts of Jeff Gable, sports information director at the college, suggest some of the characteristics of intercollegiate sport at Berry during its centennial year—the growth of the women's sport programs, the success of the soccer programs, and the international component of some of the teams. To this can be added the continuation of baseball and basketball, the first sports played at the college, as well as cross-country and tennis, which were also held in the early years of sports competition, and golf and soccer, which were added many years later. All of these sports became a part of the expansion of the program during the two decades that preceded the centennial celebration of the college, and they are a part of the Viking tradition of 2002.

The college continues to offer competition at the club sport level by fielding crew teams for both men and women, an equestrian team, and a volleyball team for women. Competing through the Intercollegiate Horse Shoe Association, the equestrian team placed fifth in the nation. The women's volleyball team, formed as a club sport in 2000, will enter intercollegiate competition in 2003. The tradition of intramurals, which began in the early years of the college, continues in a variety of activities as diverse as ultimate Frisbee, basketball, badminton, and bowling.

TODD BROOKS, ATHLETIC DIRECTOR.
In 1997, Todd Brooks replaced Bob Pearson as athletic director and became the head coach of men's basketball, a position he held until 2002. Brooks, a former basketball player at Milligan College in Tennessee, won the following awards while coaching at Berry: TranSouth Conference Eastern Division Basketball Coach of the Year in 1998–1999; Georgia Athletic Conference men's basketball coach of the year in 1995; the Whack Hyder Georgia NCAA Division III/NAIA Male Coach of the Year in 1995; and the Georgia Athletic Conference Athletic Director of the year in 1996.

JANNA JOHNSON, ASSISTANT ATHLETIC DIRECTOR. Since 1997, Dr. Janna Johnson has been the assistant and then associate director of athletics at Berry. Her principal responsibilities include assessing academic eligibility of the athletes and managing the website for athletics at the college. A graduate of Berry with a Ph.D. from Georgia State University, Dr. Johnson teaches in the Mathematical Sciences Department.

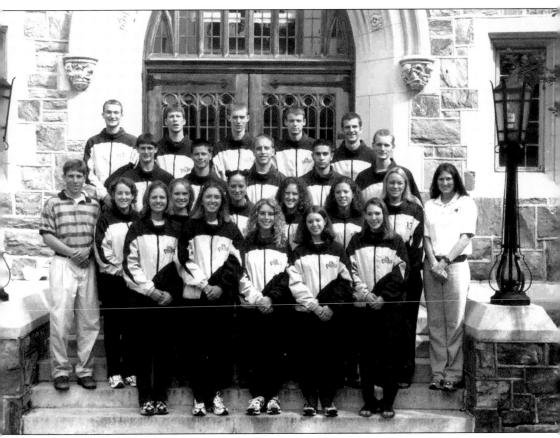

CENTENNIAL RUNNING TEAM. Pictured above are members of the Centennial Running Team. From left to right are (first row) Katie Fellows, B.J. Taylor, Rebecca Copley, Marla Goldsmith, and Joy Deaton; (second row) Head Coach Paul Deaton, Student Assistant Bekah Stroud, Erin Hardin, Delia Webster, Katie Schwab, Nora Carr, Student Assistant Cami Tarr, and Trainer Paula Meenen; (third row) Kevin Newhall, Bobby Swarthout, Brett Dettmering, Caio Soares, and Student Assistant Coach Anthony Daniell; (fourth row) Jay Stephenson, Jonathon Sutton, Zach Huston, David Fogg, and Brad Franklin.

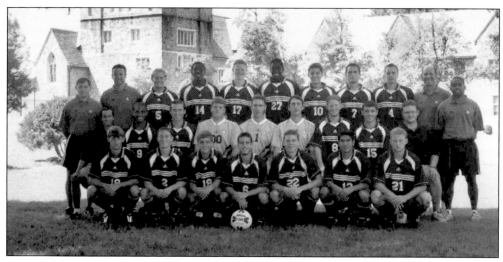

CENTENNIAL MEN'S SOCCER TEAM. Pictured above are members of the Centennial Men's Soccer Team. From left to right are (front row) Lanier Gaines, Chris McMichael, Josh Cremeens, Paul Jeffries, Hunter Thornton, Mauricio Castro, and Matthew Wiggins; (middle row) Student Trainer Matt Hunter, Steve Gathany, Daniel Niedzkowski, Scott Dunford, Byron Schueneman, Joe Zorbanos, Steve Young, Benjie McKendry, and Athletic Trainer Tim Tolbert; (back row) Student Assistant Rex Bowman, Assistant Coach Richard Vardy, Eddie Loewen, Sherwin Seifert, Greg Young, Trevin Nairne, Manolo Schurmann, Jeff Dolbeer, Derek Reid, Head Coach Kurt Swanbeck, and Student Assistant Adrian Perez.

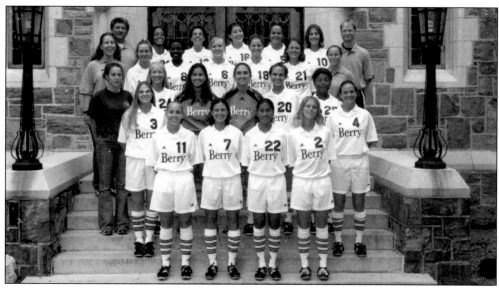

CENTENNIAL WOMEN'S SOCCER TEAM. Pictured above are members of the Centennial Women's Soccer Team. From left to right are (first row) Katie Tolbert, Miriam Galeas, Audrey Fonnegra, and Becky Ferguson; (second row) Trainer Elizabeth Bonner, Kristin Johnson, Karina Lopez, Brenda Mikalajunas, Robin Dolbeer, Lisa Backlund, and Lauren Marziliano; (third row) Team Manager Jessica Stipcak, Alli Hannon, Jamila Cross, Jessie Williamson, Ashleigh Waters, Jessica Wilson, and Student Assistant Dee Campanella; (fourth row) Head Coach Lorenzo Canalis, Myau Jenkins, Cathryn Slasinski, Leah Updegrave, Sara Schoeplein, Jenna McEwan, and Assistant Coach Eric Gentilello.

CENTENNIAL WOMEN'S GOLF TEAM. Pictured above is the Centennial Women's Golf Team. From left to right are (front row) Nikki Davis, Jacqueline Randolph, Shena Williams, Elizabeth Byrd, and Erica Wilson; (back row) Head Coach Scott Pierce.

CENTENNIAL MEN'S GOLF TEAM. Pictured above is the Centennial Men's Golf Team. From left to right are (front row) Joe Fife, Blake Cone, Robbie Niedergall, Stan Cole, and Boris Bruckert; (back row) Assistant Coach David Goddard, Zane Goldthorp, Brian Farrer, Head Coach Scott Pierce, Adam Britt, Blake Smart, and Clay Kitchen.

CENTENNIAL WOMEN'S BASKETBALL TEAM. Pictured above is the Centennial Women's Basketball Team. From left to right are (front row) Team Manager Sasha Hammac, Student Assistant Rachel Roberts, Student Trainer Lindsay Erwin, Katie Vermilya, Student Assistant Emily Woody, Assistant Coach Kaye Waldrep, and Head Coach Jim Izard; (middle row) Jessica Burdine, Autumn Brown, Brooke Bowen, Beth Bankston, and Mekia Troy; (back row) Lindsey Bouldin, Natalie Cooke, Sheri Brooks, Cassandra Seifert, and Leasha Raburn.

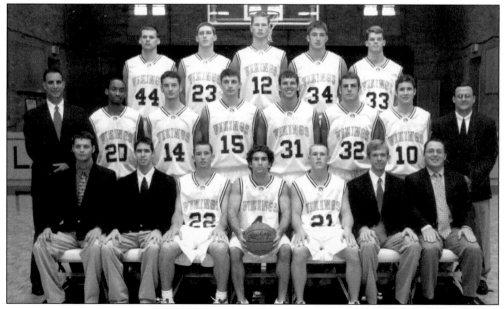

CENTENNIAL MEN'S BASKETBALL TEAM. Pictured above is the Centennial Men's Basketball Team. From left to right are (front row) Student Assistant Brad Steinhauer, Team Manager Justin Kier, Cameron Fitch, Trent Campbell, Josh Hembree, Student Trainer Matt Grisham, and Assistant Coach Jeff Haarlow; (middle row) Assistant Coach Tony Caruso, Stacey Scotton, Brian Johnston, John David Gable, Lucas Romine, Kirk Feinswog, Sean Henry, and Head Coach Todd Brooks; (back row) Eric Herrick, Brad Smith, Marc Michiels, Jonathan Reddell, and Duane Tippets.

CENTENNIAL MEN'S TENNIS TEAM. Pictured above is the Centennial Men's Tennis Team. From left to right are (front row) Bo Wright, Matt Marsico, and Coach Clay Hightower; (back row) Dennis Den Boer, Marc Duckeck, Alberto Lara, Markus Karlsson, and Sven Plass.

CENTENNIAL WOMEN'S TENNIS TEAM. Pictured above is the Centennial Women's Tennis Team. From left to right are (front row) Amy Herendeen and Jenny Pierce; (back row) Carrie Thomason, Coach Clay Hightower, Wissal Ben Khalifa, Susannah Cook, Paisley Hines, and Liz Dillinger.

CENTENNIAL MEN'S VARSITY BASEBALL TEAM. Pictured above is the Centennial Men's Varsity Baseball Team. From left to right are (front row) Josh Gernatt, Corey Teem, Bradley Smith, Lance Culpepper, Nick Sun, Scott Wood, Sammy Willoughby, Russ Hunt, and Jared Kime; (middle row) Head Coach David Beasley, Assistant Coach Corey Gochee, Josh Griffith, Josh Beshears, Nick Hopper, Patrick Stevens, Ben Evans, Jeremy Hannah, Scott Way, Michael Moore, Braden Ashworth, Assistant Coach Jarrett Bridges, and Assistant Coach Todd Jenkins; (back row) Tim Borders, Nate Mosteller, Kerry Shouldeen, Travis Hope, Brett Myers, Ryan Deems, Jonathan Neighbors, Brian Schwanbeck, Tyler Coats, Matt Zacher, and Thom Emmons.

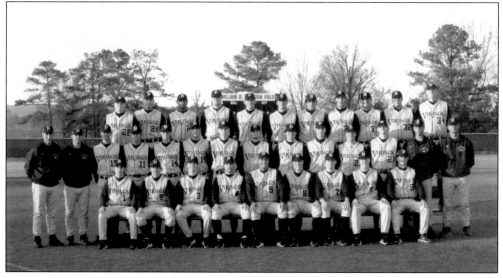

CENTENNIAL MEN'S JUNIOR VARSITY BASEBALL TEAM. Pictured above is the Centennial Men's Junior Varsity Baseball Team. From left to right are (front row) Matt Floyd, Braden Ashworth, Nathan Bower, Scott Howard, Dereck Corn, Nick Hopper, Michael Smith, Mason Brackett, and Austin Posey; (middle row) Coach Corey Gochee, Nate Berryman, Ben Perry, Steve Tkac, Brett Myers, Matt Lucas, Wesley Fields, Ben Evans, Marshall Flynt, Mark Floyd, Thom Emmons, Matthew Groce, and Coach Todd Jenkins; (back row) Nicholas Ham, Brandon Reece, Josh Muse, Emmett Jordan, Nick Amiano, Adam Pugh, Matt Sullivan, Joseph Forrest, Jonathan Neighbors, Patrick Stevens, and Jack Cash.

CENTENNIAL TRAINERS. Pictured from left to right are Head Trainer Ginger Swann, Assistant Trainer Aaron King, Graduate Assistant Tim Tolbert, and Graduate Assistant Jessie Ayer.

CENTENNIAL CHEERLEADERS. Shown here are the Centennial Cheerleaders. From left to right are (front row) Mandy Dellinger, Brandon Jackson, Crystel Singletary, Anna Kerr, Kevin Ingram, and Mary Elizabeth Voyles; (back row) Evan Conlon, Ben Horton, Joey Ray, Lindsay Teem, Patrick Ouzts, Kelly Abbott, Lawson Bost, and Julie Riggs.

INDEX OF PEOPLE

121

Vanlandingham, Stephen (1926) 36
Vannerson, Wendy Marie (1996) 106
Vardy, Richard (coach) 114
Vargas, Edmundo (1965) 85
Verlander, Philip(1992) 104
Vermilya, Katie 116
Voyles, Mary Elizabeth 119
Vroom, Jim 72
Waddell, Blair (1997) 106
Wagstaff, Gerald (1975) 78
Waldrep, Kay (coach) 116
Walker, _____ 49
Walker, Rick (1970) 85
Waller, Marilyn 65
Walsh, Geoff (1992) 98
Walton, Josh (1990) 94
Walton, Matthew Cowan (1995) 106
Ward, Jane (1959) 60
Warming, Bob (coach) 84, 85
Watson, Herman A. (1924) 33
Waters, Ashleigh 114
Way, Scott 118
Weatherford, Charlie (1957) 59
Weaver, Joseph Walter (1907) 11
Webb, Maurice (1959) 62
Webster, Delia 113
Weech, Jack 64
Welch, Carl (1950) 55
Weldon, _____ 26
Weldon, Lisa (1985) 92
West, Daniel (1974) 108
West, Susan 97
Westmoreland, Gene (1963) 70
Whiddon, _____ 49
Whitaker, James Hobart (1915) 24
White, David 79
White, Eunice (1914) 15
White, Karen (1972) 94
White, Mary (1914) 15
White, Troy (1978) 79
Whiteside, Charles B. (1911) 23
Whitlow, Frank 11
Whittle, Heath (1926) 36, 37
Wiggins, Matthew 114

Wiggins, Ron (1992) 98
Wilcher, Bob (1967) 72, 78, 85
Wilkie, Charles (1976) 79
Williams, _____ 49
Williams, "Hot Shot" 36
Williams, Brandi (1999) 92
Williams, Carolyn (1965) 70
Williams, Elsie 28
Williams, Red 59
Williams, Shena 115
Williamson, Jessie 114
Williamson, R.G. 11
Willoughby, Sammy 118
Wills, _____ 26
Wilson, Amanda (1990) 95
Wilson, Donovan 55
Wilson, Carol (1967) 76
Wilson, Donald 54
Wilson, Erica 115
Wilson, Jessica 114
Wilson, Johnny 72, 78
Wilson, Rodney (1991) 93
Wilson, Sherry (1980) 107
Wimberly, Mary Lucy (1964) 70
Winnick, Jennifer (1997) 106
Witherington, Will (1995) 104
Womble, Buck 59
Wood, _____ 24
Wood, Scott 118
Woodruff, Barbara 73
Woody, Emily 116
Wooly, Ed 11
Wootan, John 84
Worede, Yohannes (1985) 84
Worley, Stanley (1969) 77
Worth, Nikki 109
Wright, Bo 17
Wright, William Price (1907–1909, coach) 11
Wyatt, Luther (1921H) 32
Wyatt, Martha (1955H, 1959C) 57
Wyatt, Nat (1938) 46
Wynn, Joe 11
Yoda, Koji (1965) 85
Young, Greg 114
Young, John C. 30
Young, LeRoy (1923) 33
Young, Steve 114
Zatcher, Matt 118
Zebeau, JoAnn (1982) 83
Zorbanos, Joe 114